BRITAIN BY NIGHT

MARK McNEILL

AMBERLEY

First published 2022

Amberley Publishing
The Hill, Stroud
Gloucestershire, GL5 4EP

www.amberley-books.com

Copyright © Mark McNeill, 2022

The right of Mark McNeill to be identified as the Author of this work has been
asserted in accordance with the Copyrights, Designs and Patents Act 1988.

ISBN 978 1 3981 0245 3 (print)
ISBN 978 1 3981 0246 0 (ebook)

British Library Cataloguing in Publication Data.
A catalogue record for this book is available from the British Library.

Typesetting by SJmagic DESIGN SERVICES, India.
Printed in the UK.

ACKNOWLEDGEMENTS

A big thank you to my wife and family – Maisy, Martha and Hope – for putting up with lots of late nights. Thank you to Professor Brian Cox and Tim Peake for giving me support and sharing my photographs on social media. A big thank you to Dave Zdanowicz for all his help and advice on all things book related, and for recommending a few brilliant Yorkshire locations to visit. A massive thanks goes to the makers of the equipment I have used: to Nikon for the camera; Formatt Hitech for their continued support and Nightscape filter, which helps reduce light pollution; 3 Legged Thing for epic, sturdy tripods; and to OPPO UK for their OPPO Find X5 Pro mobile phone, which helped me capture shots in London.

ABOUT THE PHOTOGRAPHER

Mark McNeill, a landscape and astro photographer from the north-west of England, has a passion for landscape photography that started over fifteen years ago. Some of his favourite locations are based in the English Lake District and Glencoe, Scotland. He won the award for Astronomy Photographer of the Year in 2018 with his image *Me Versus the Galaxy*, which was in the People and Space category. It was featured in *National Geographic* magazine and by Collins Astronomy. He has had features in Sigma Lounge, and *Practical Photography* magazine shortlisted him for Science Photographer of the Year in 2021 for the Royal Photographic Society.

Website: markmcneillphotography.com

INTRODUCTION

The idea for this book was to try and capture Britain in a unique way. Most people take photos during the day; well, I get a buzz out of taking photos at night, so I thought I'd travel the whole of Britain.

I journeyed from my home town in Preston to Scotland, Wales, Northumberland, the east coast, London, Manchester, Liverpool, Birmingham – you name it, I tried to travel there. I travelled to lots of places and didn't even manage to take a photo due to rain, wind or traffic. So many things got in my way – even Covid-19.

The images are mainly of famous landmarks in our towns and cities. Some of the most amazing places are in the darker locations, such as Northumberland, the Lake District, Hermitage Castle in the Scottish Borders, and Anglesey in Wales. Even more exciting is the capital city,

London, or the city centre of Manchester – adding the movement of cars and buses adds a bit of interest into a busy area.

I really hope you enjoy these images and that you have a chance to visit some of these places. It might even inspire you to take similar photos near where you live or, perhaps, when it gets dark, to venture a little further out and try and capture some further afield. A good tip, I would say, is always try and bring a tripod with you, or rest your camera on something like a wall or beanbag. When you do night photography you need to do long exposures, mainly because it's so dark, and you need to hold the camera for at least five to ten seconds to capture an image. So, if you're not able to hold it steady the images will turn out blurry. That is my top tip of the day!

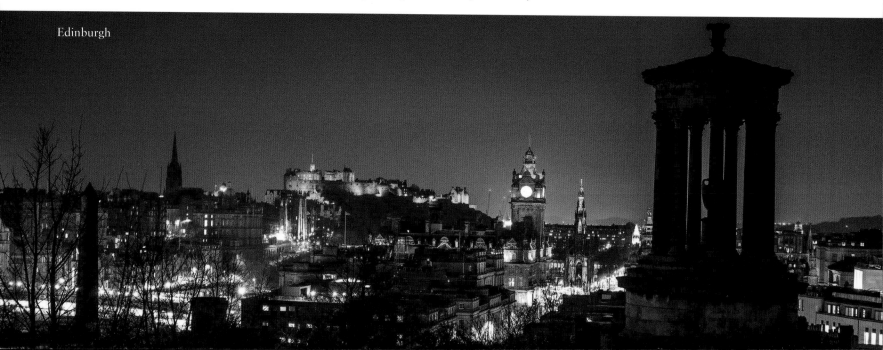

Edinburgh

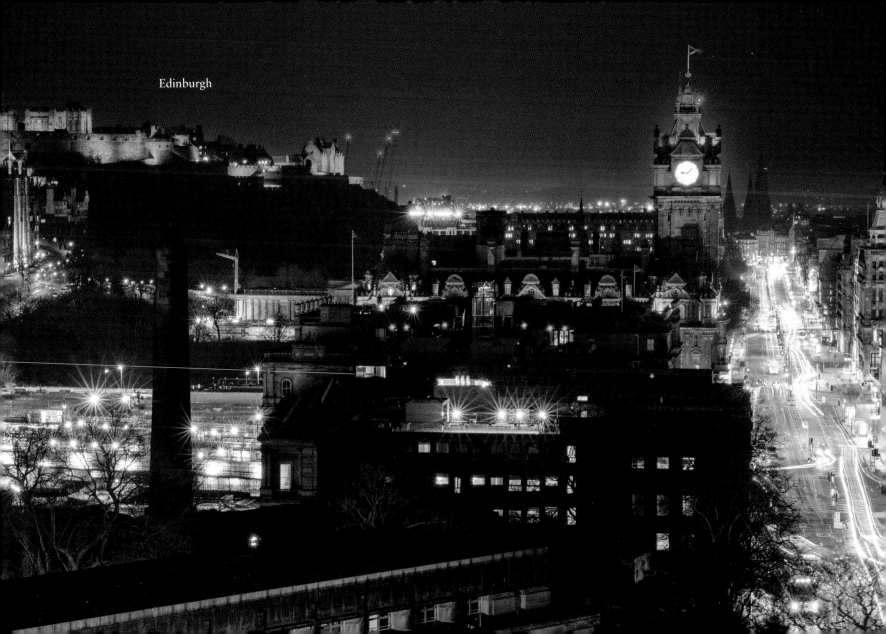
Edinburgh

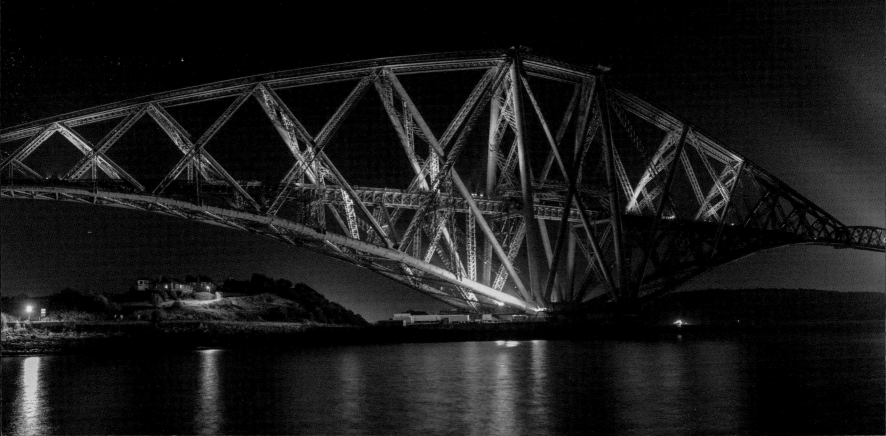

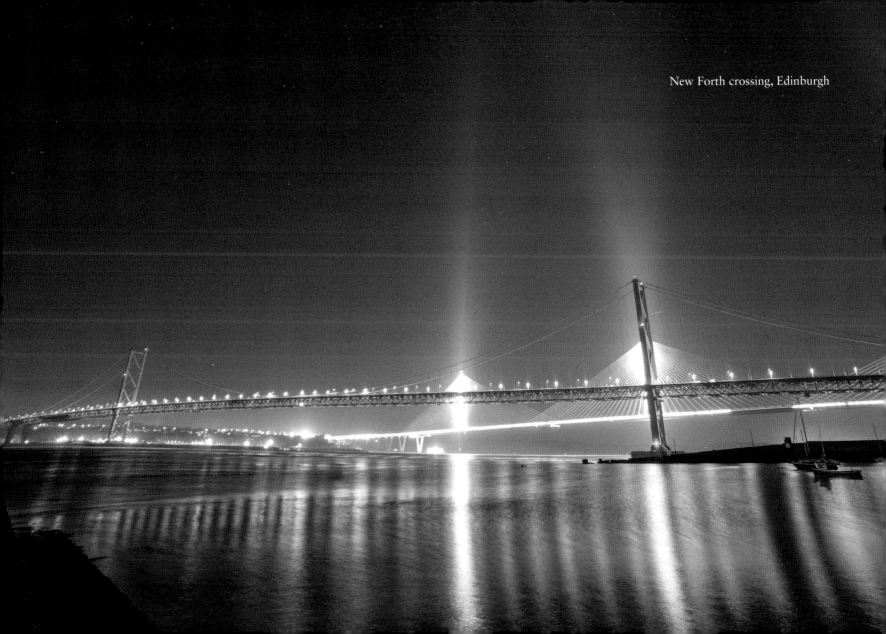

New Forth crossing, Edinburgh

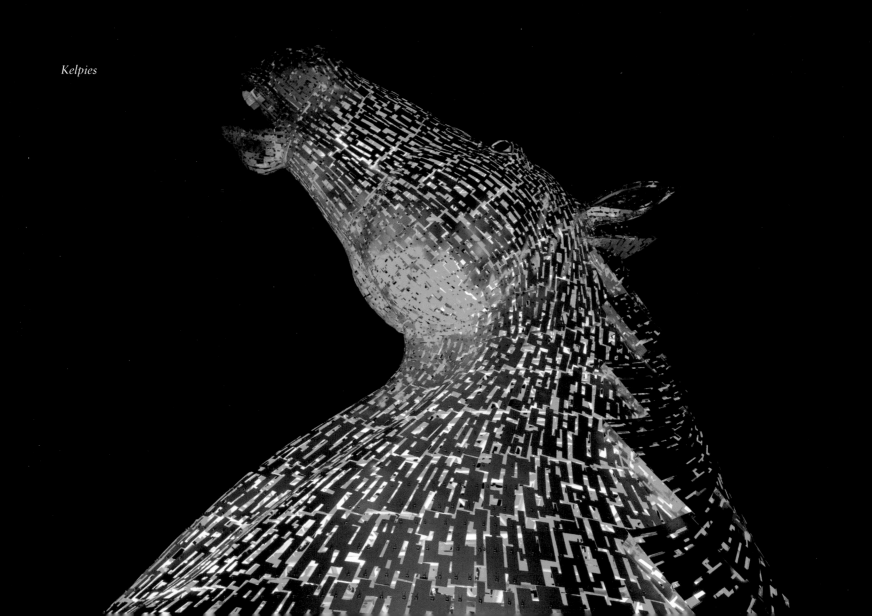

Kelpies

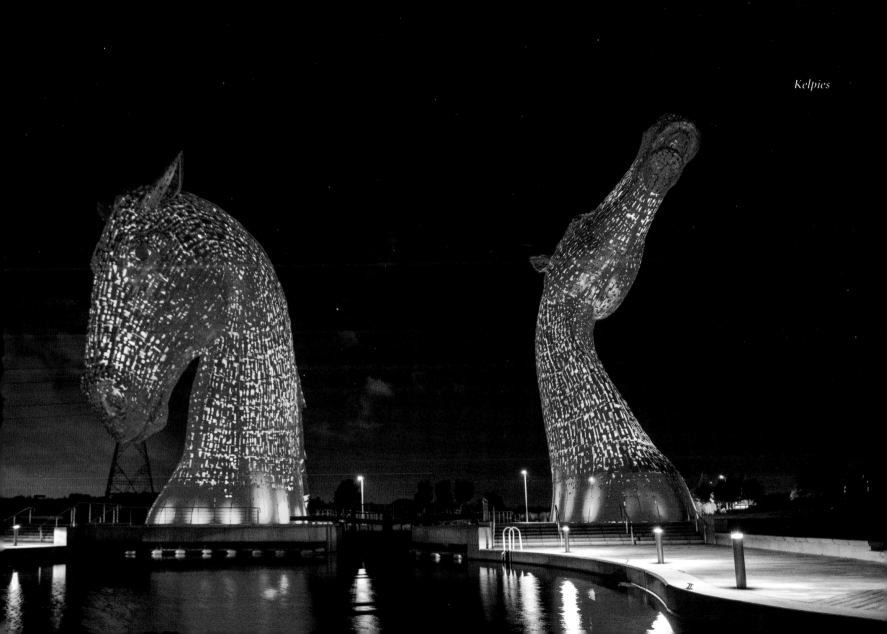

Kelpies

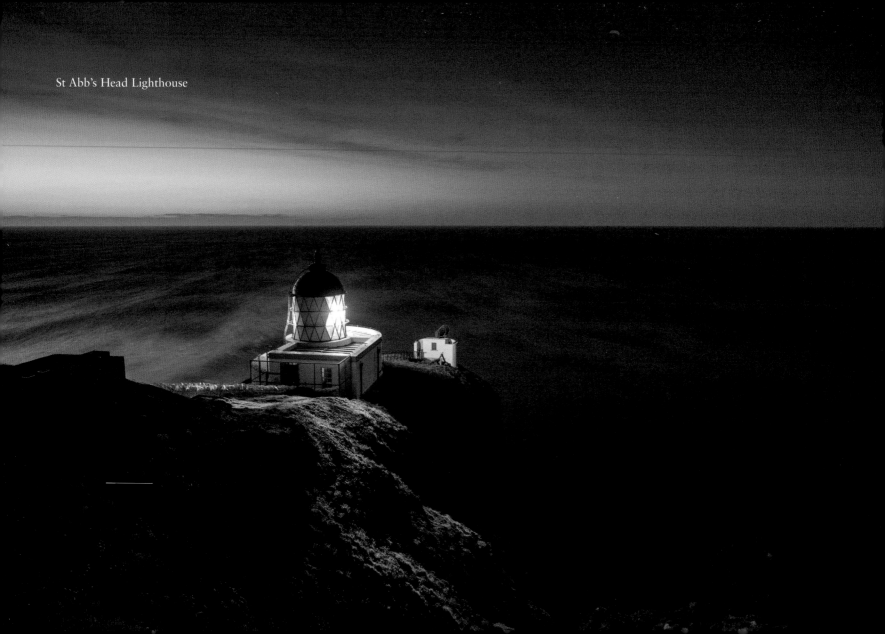

St Abb's Head Lighthouse

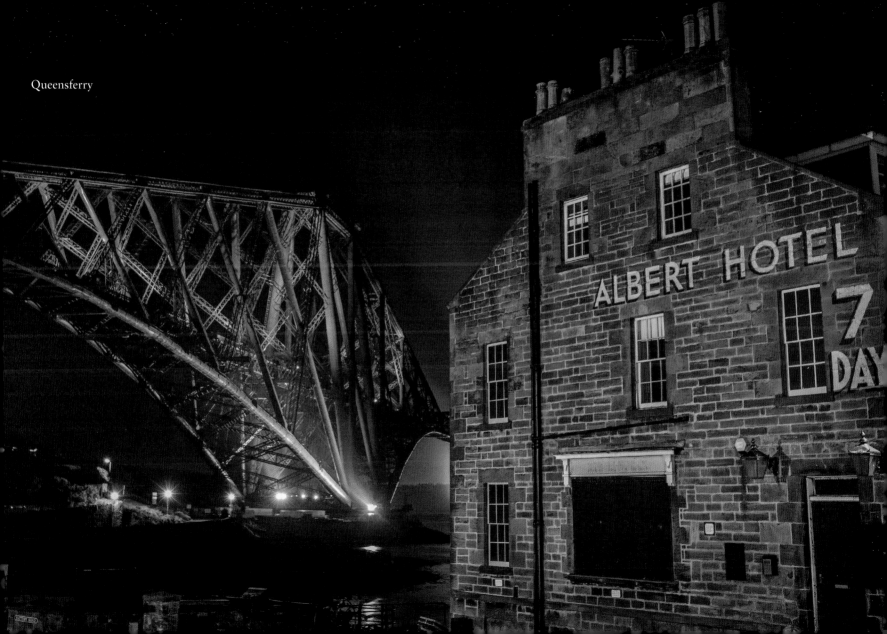

Queensferry

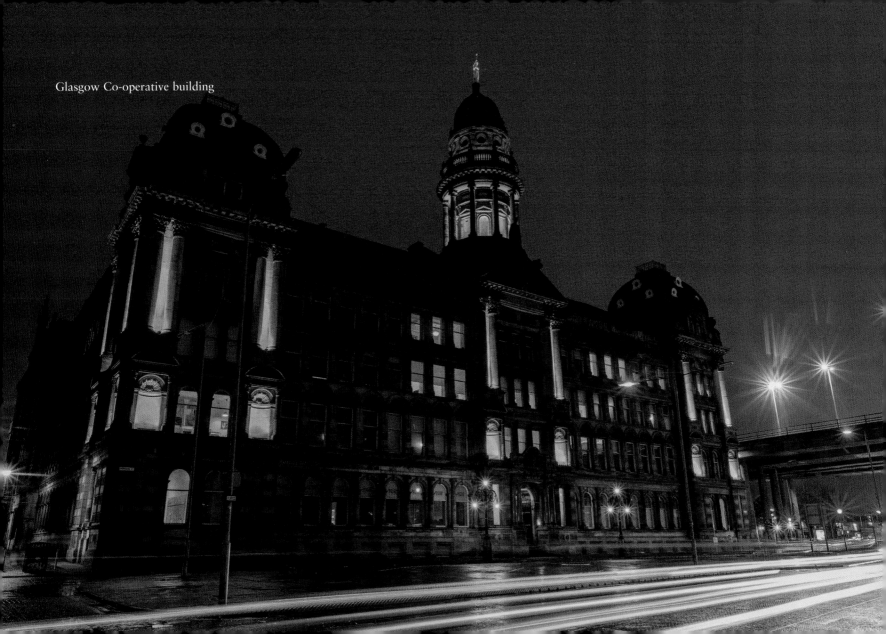
Glasgow Co-operative building

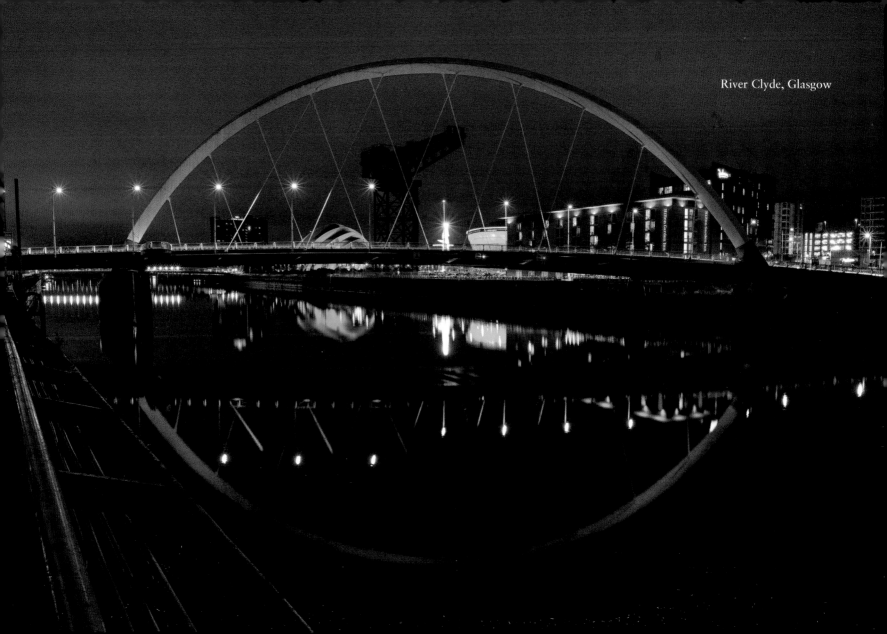

River Clyde, Glasgow

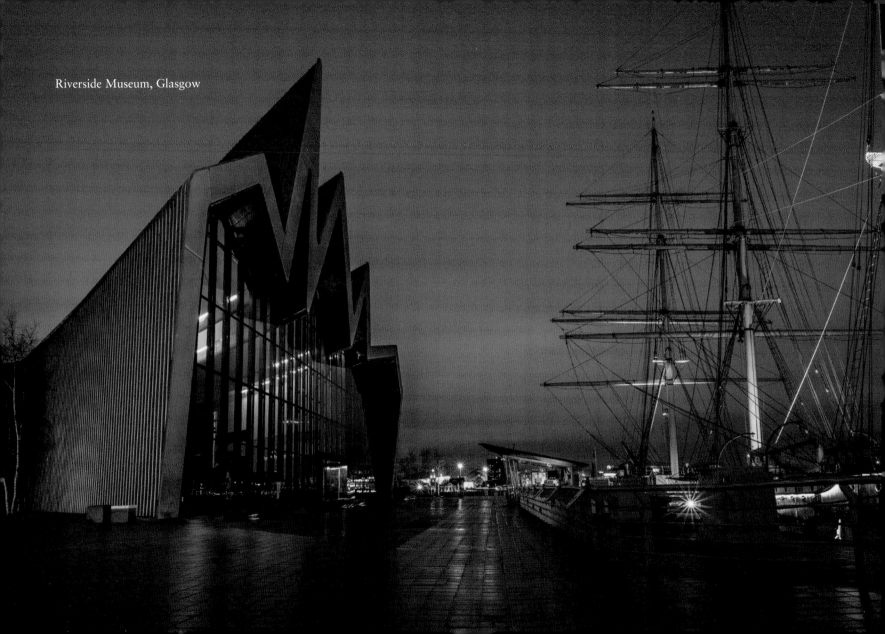

Riverside Museum, Glasgow

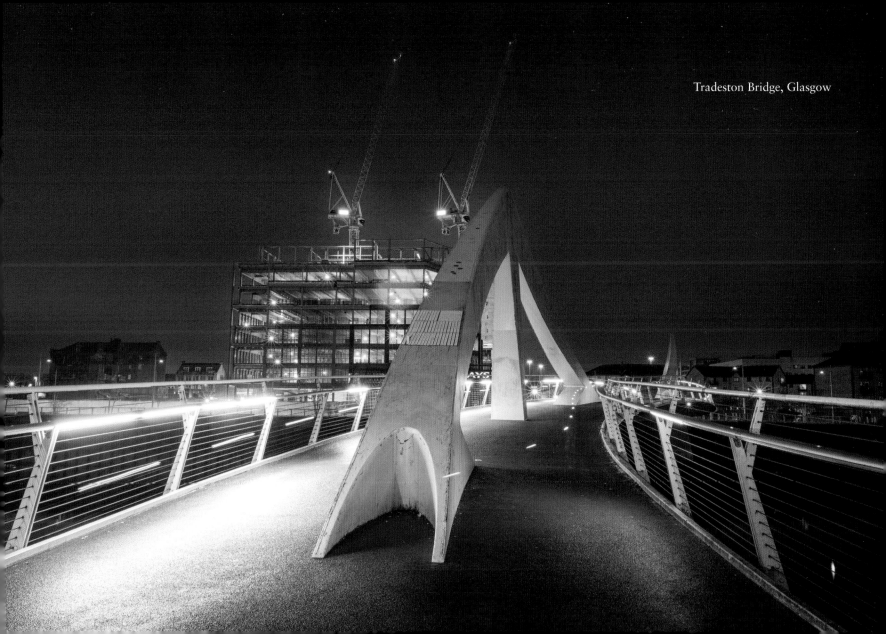
Tradeston Bridge, Glasgow

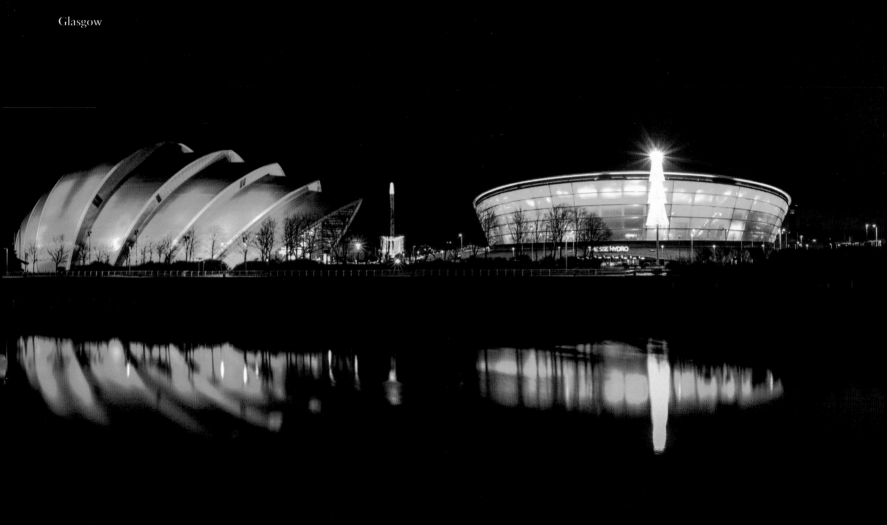

Glasgow

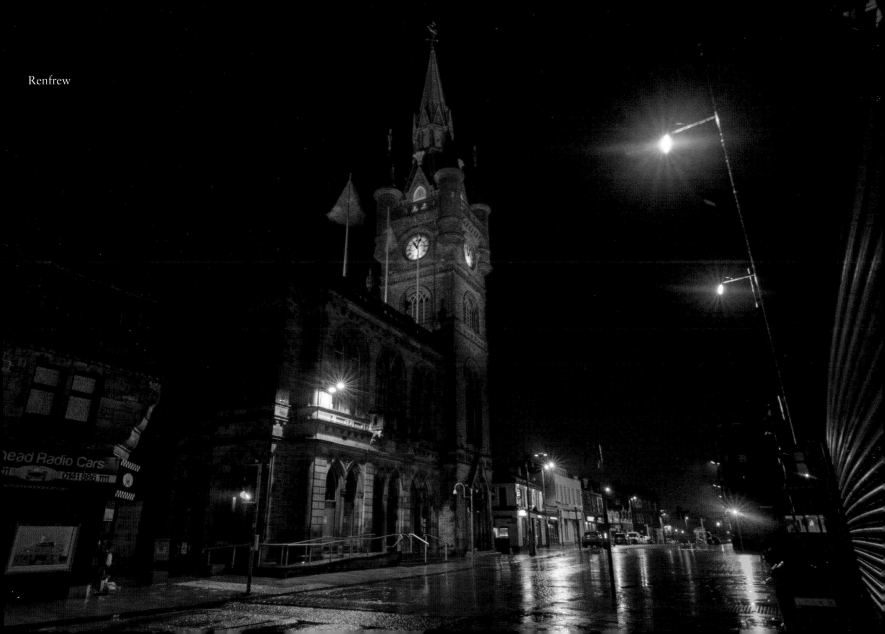

Renfrew

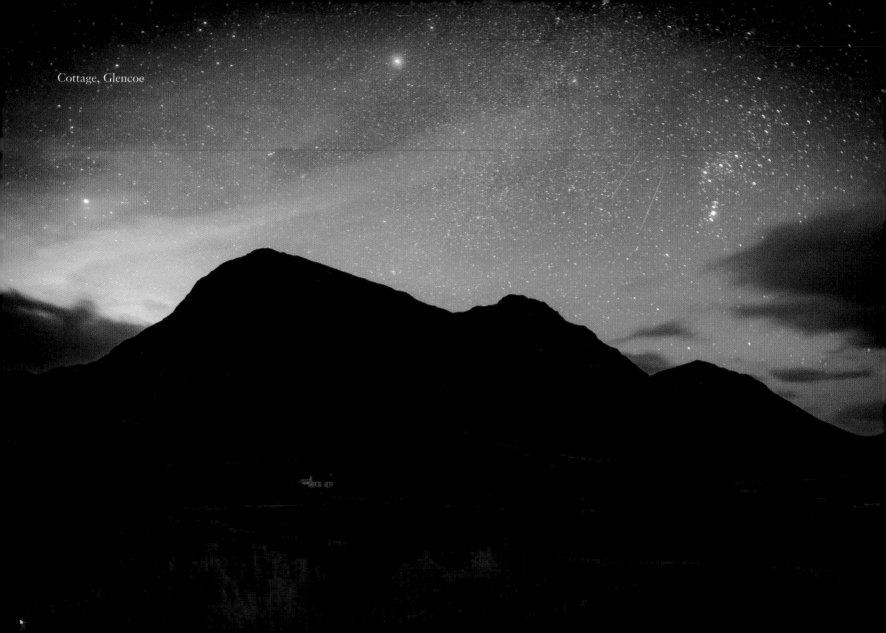

Cottage, Glencoe

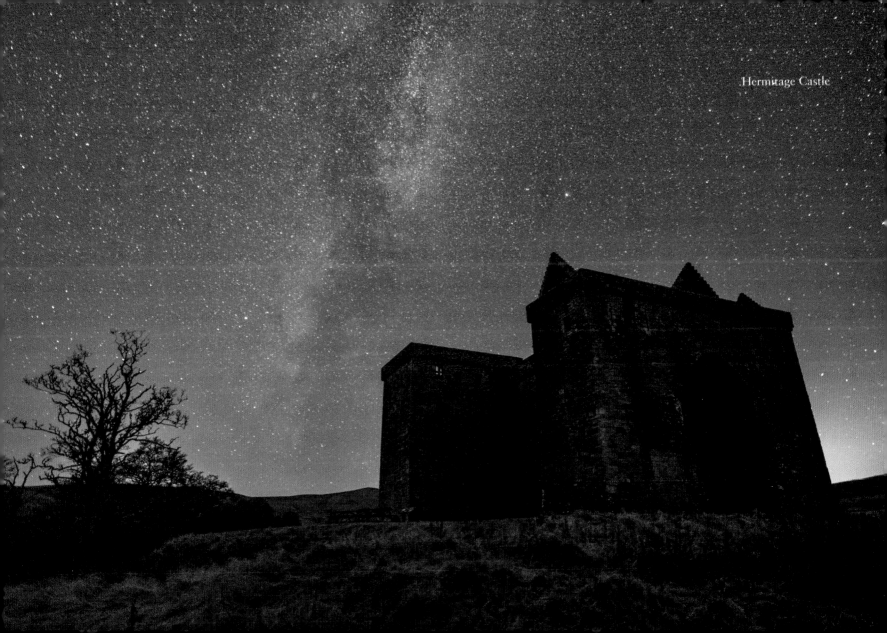

Hermitage Castle

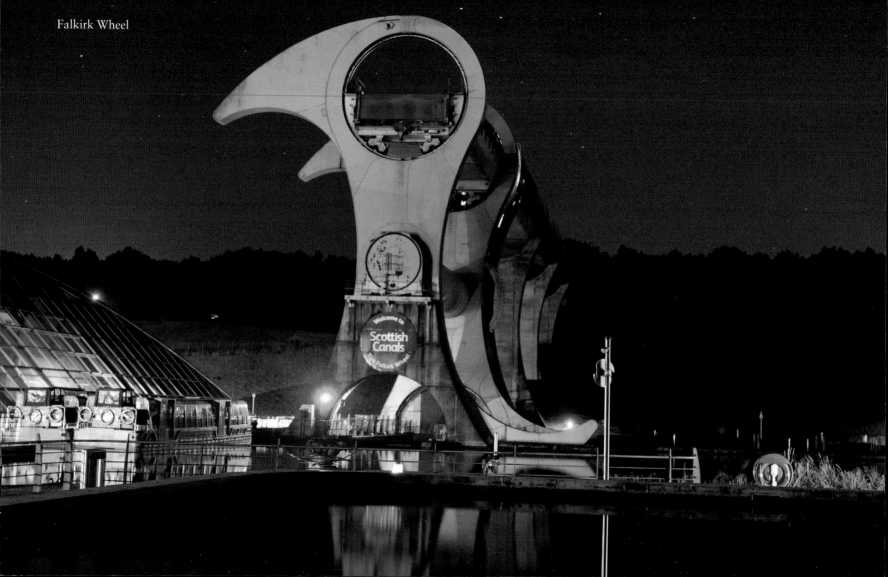
Falkirk Wheel

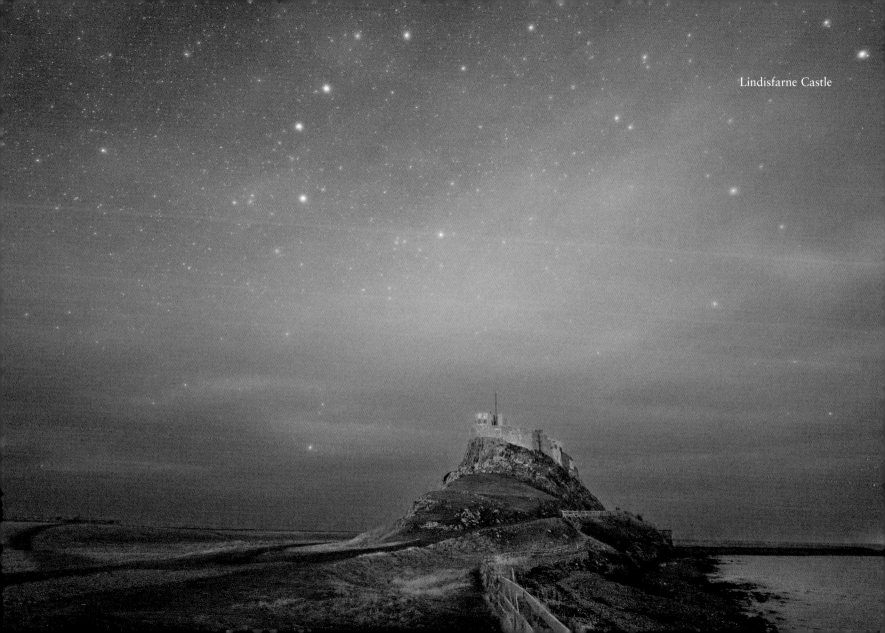
Lindisfarne Castle

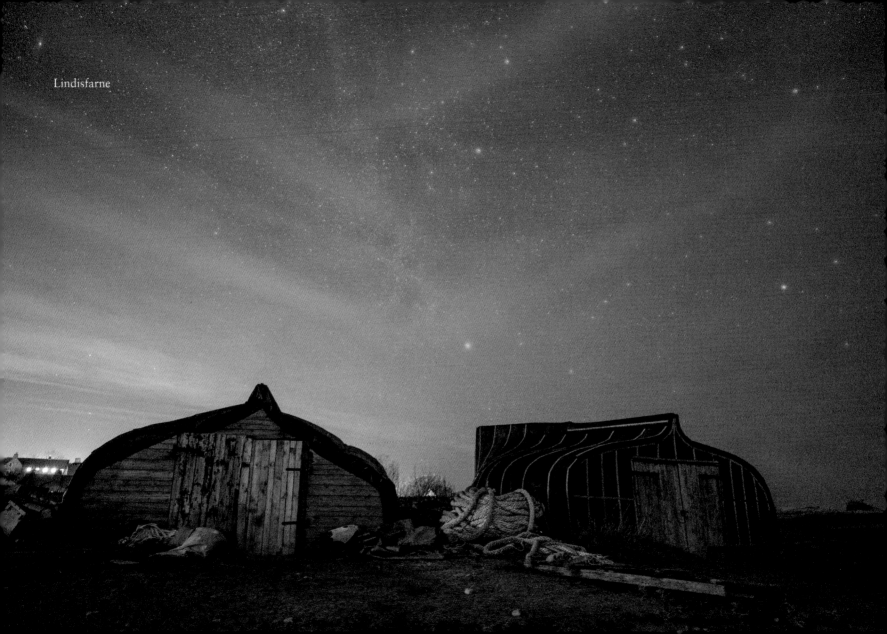

Lindisfarne

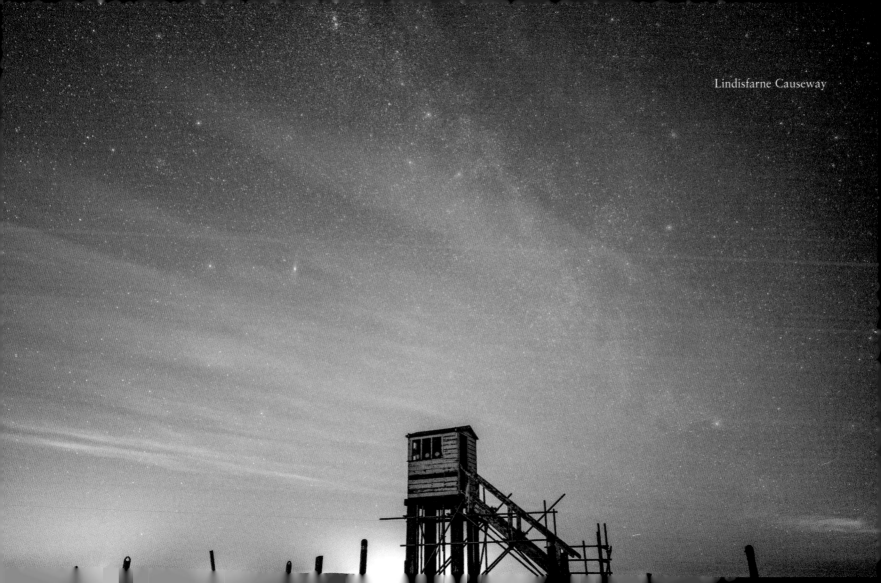

Lindisfarne Causeway

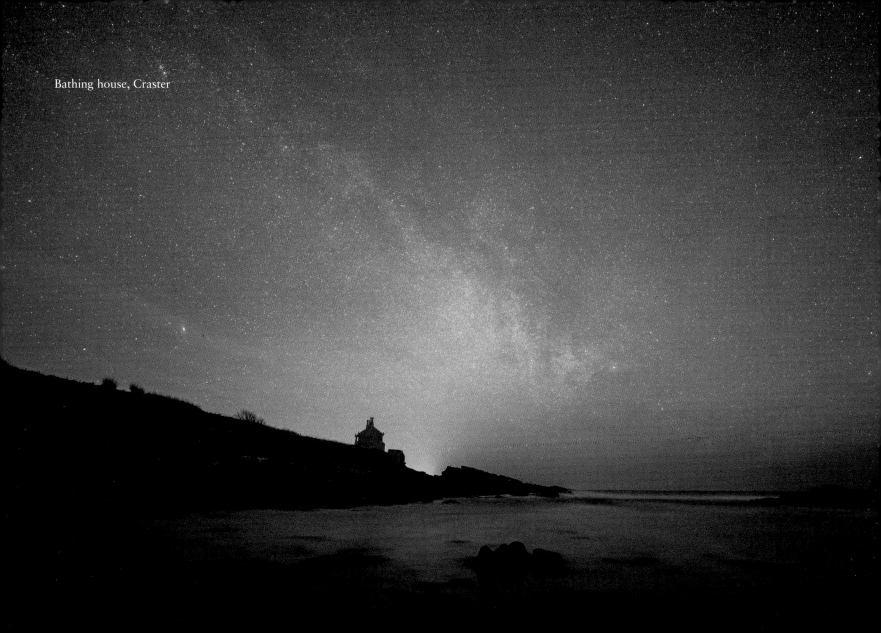

Bathing house, Craster

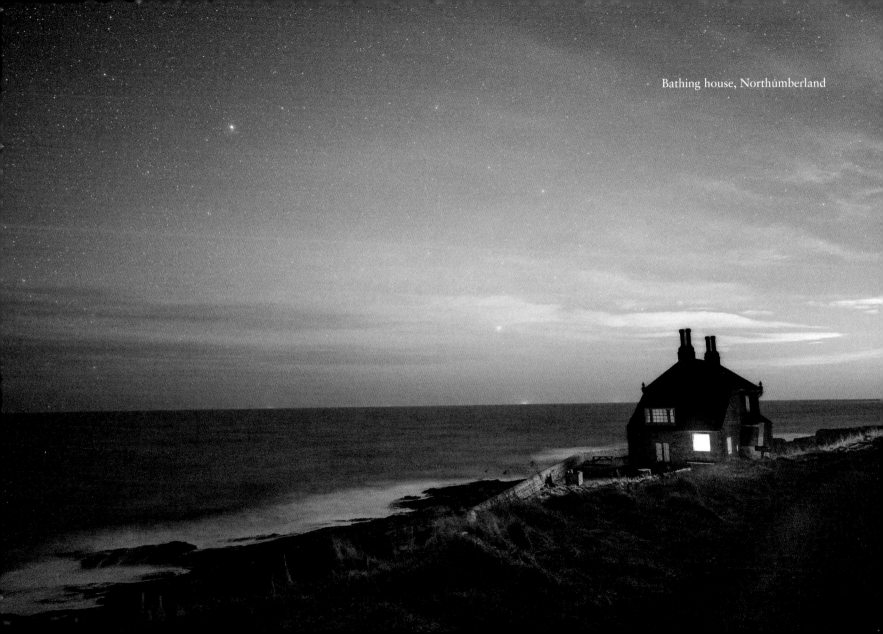

Bathing house, Northumberland

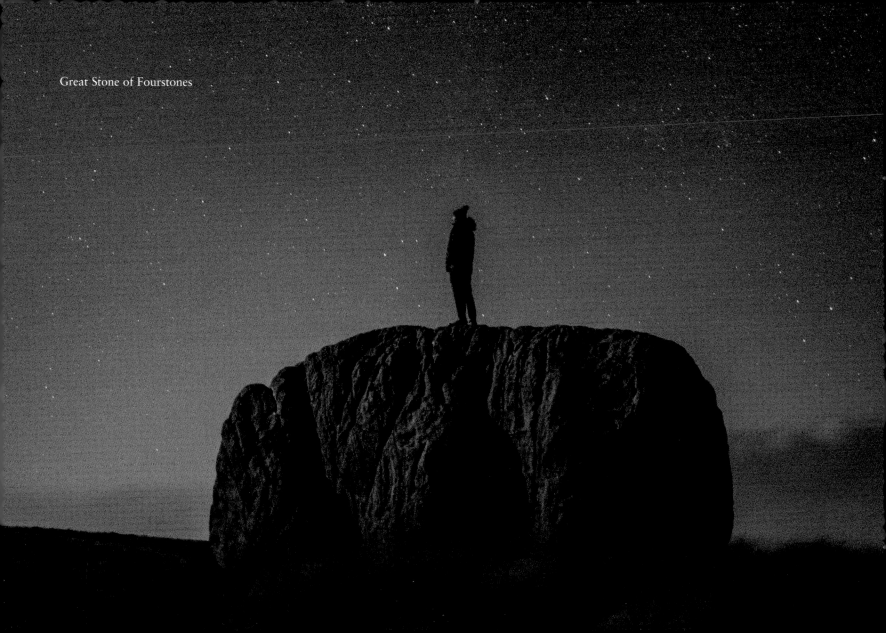

Great Stone of Fourstones

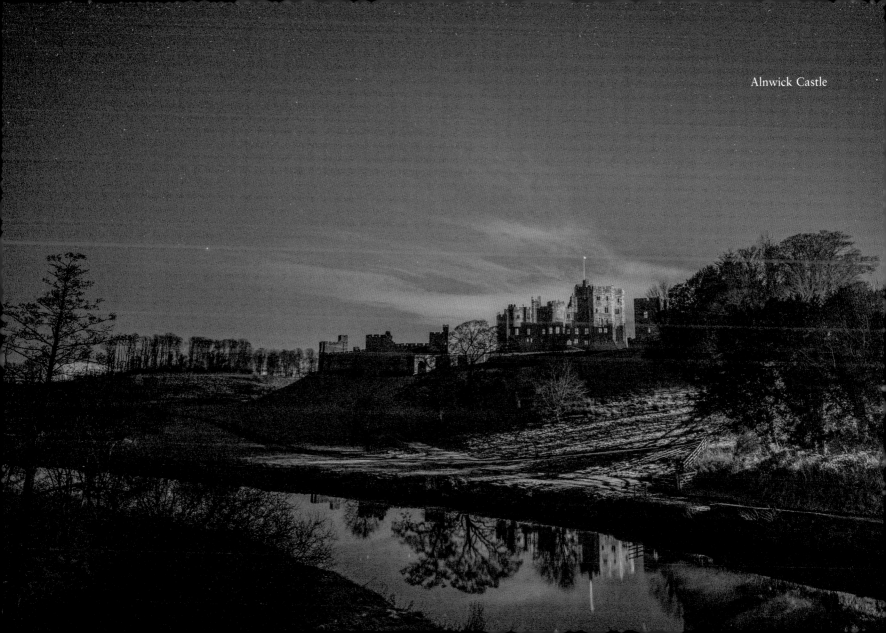

Alnwick Castle

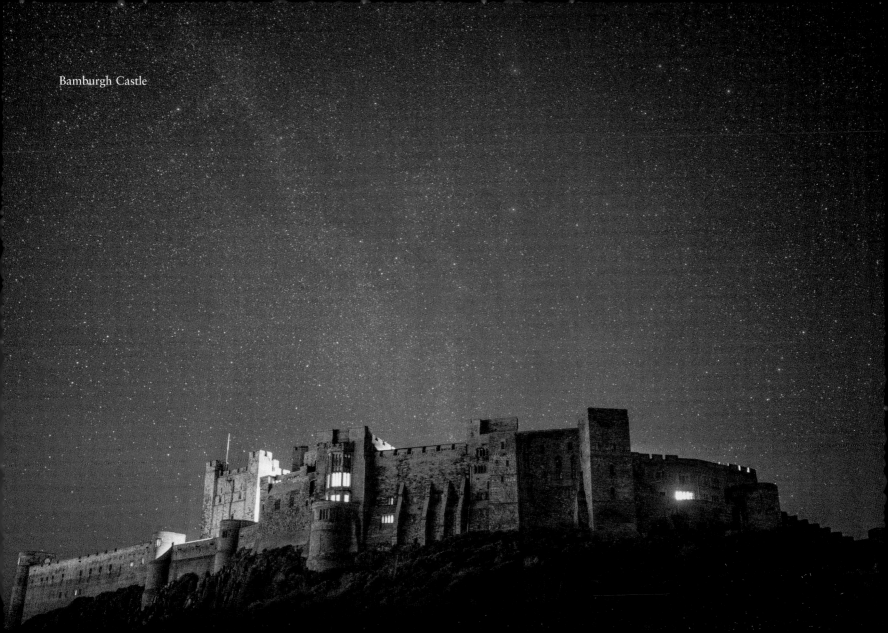

Bamburgh Castle

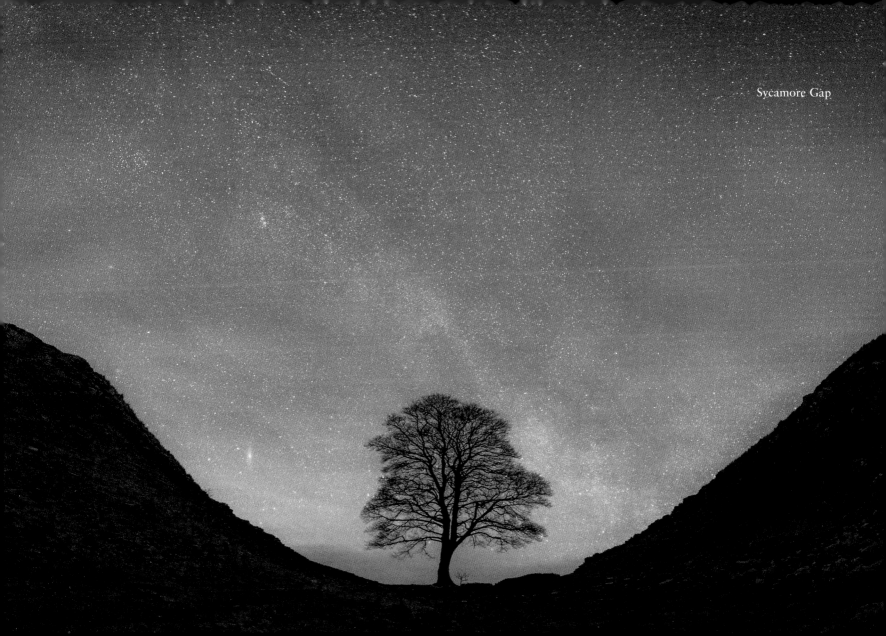

Sycamore Gap

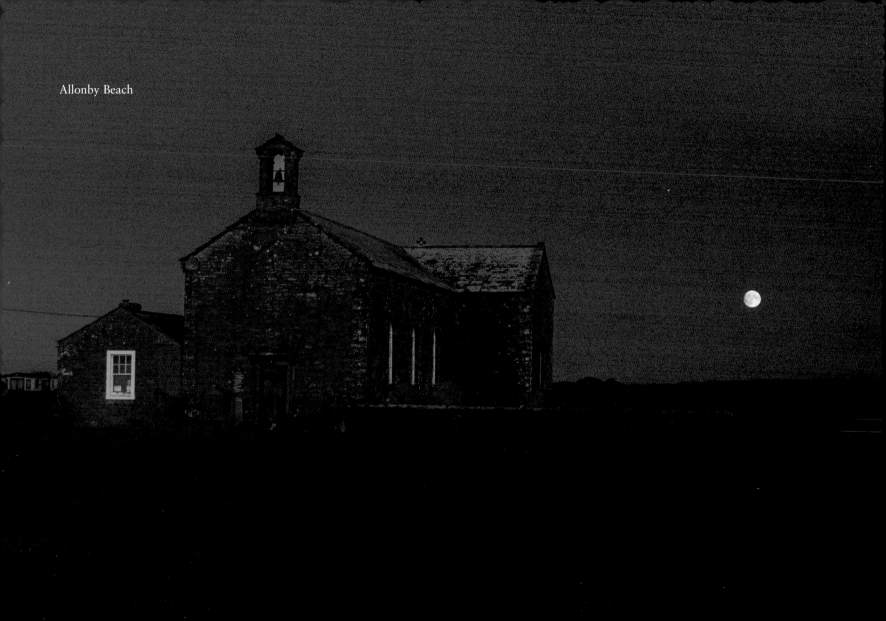

Allonby Beach

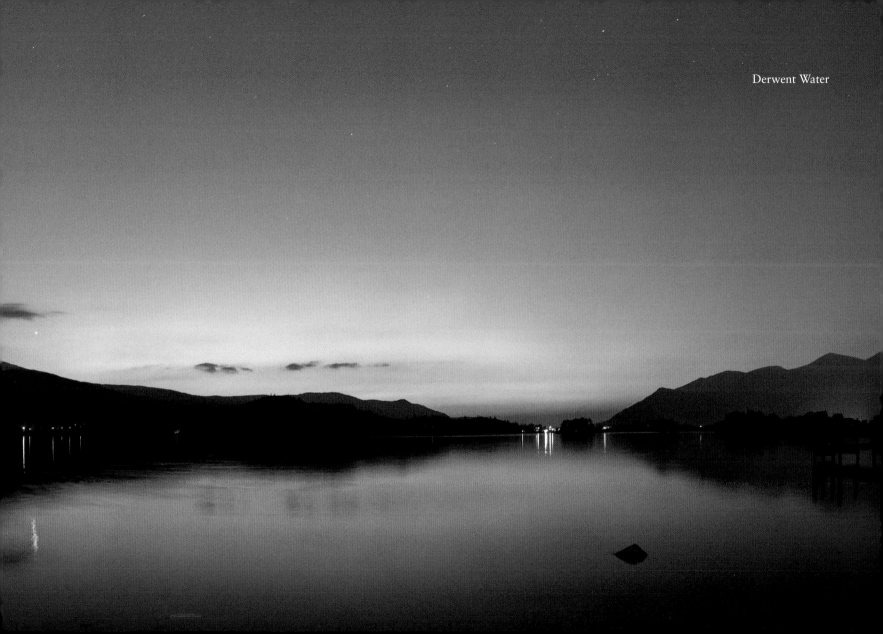

Derwent Water

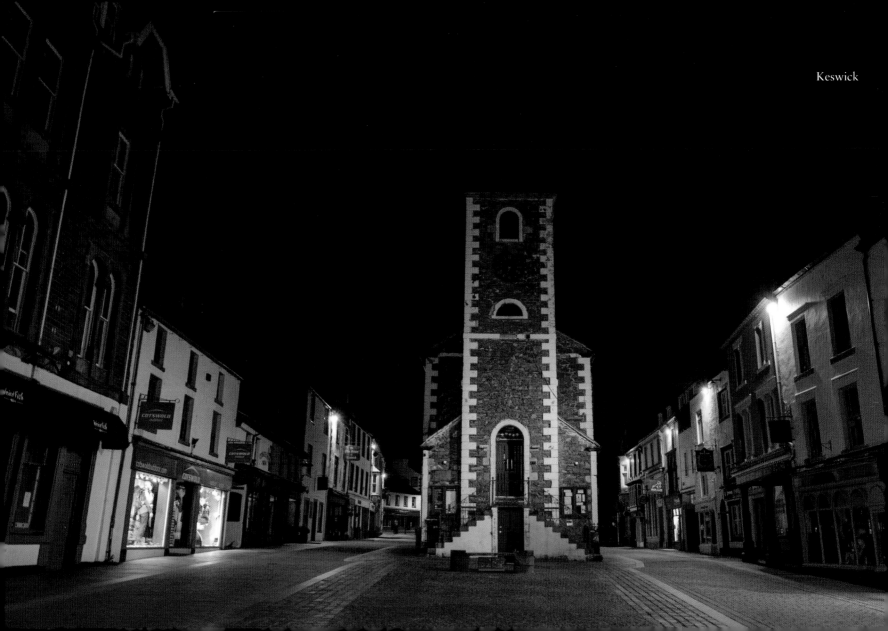

Keswick

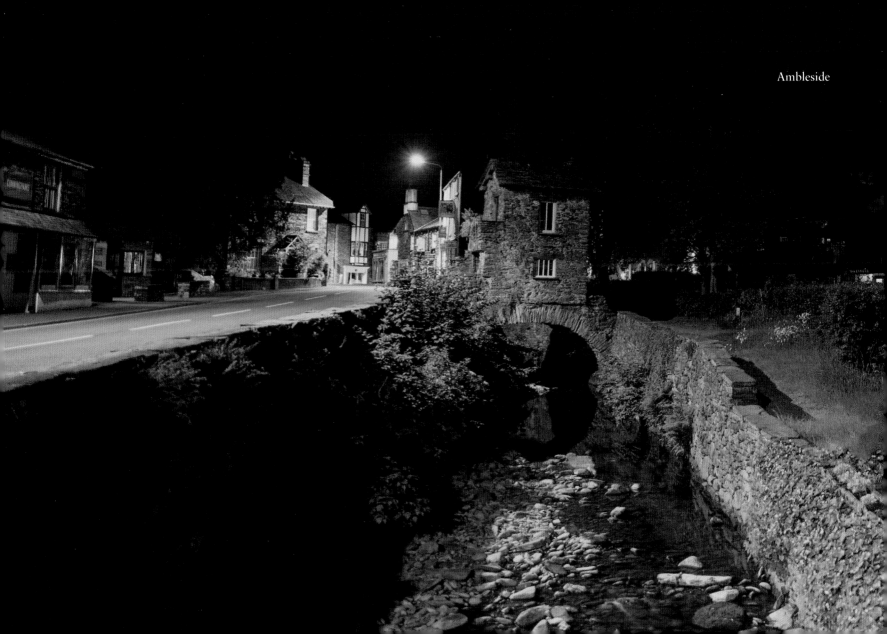
Ambleside

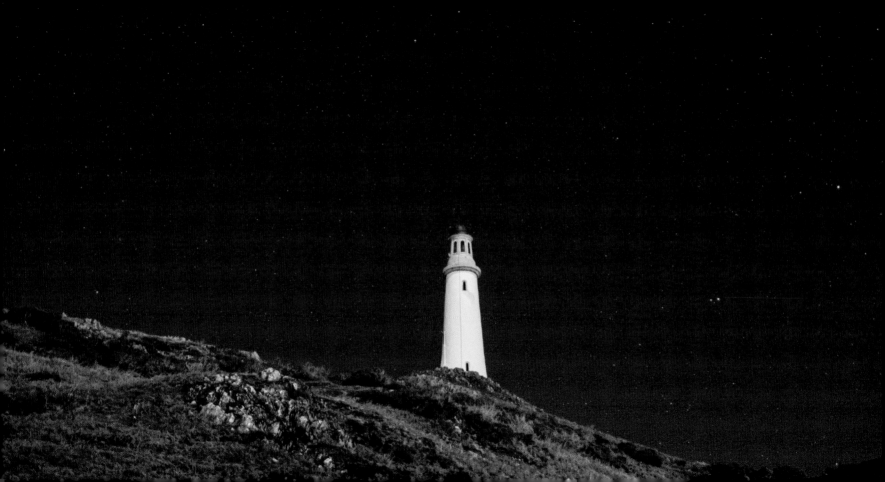

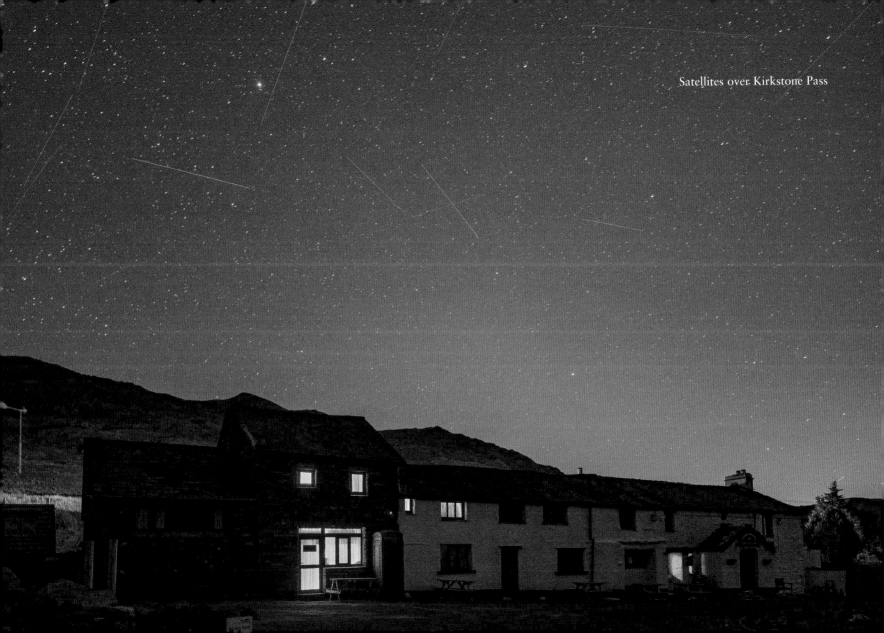
Satellites over Kirkstone Pass

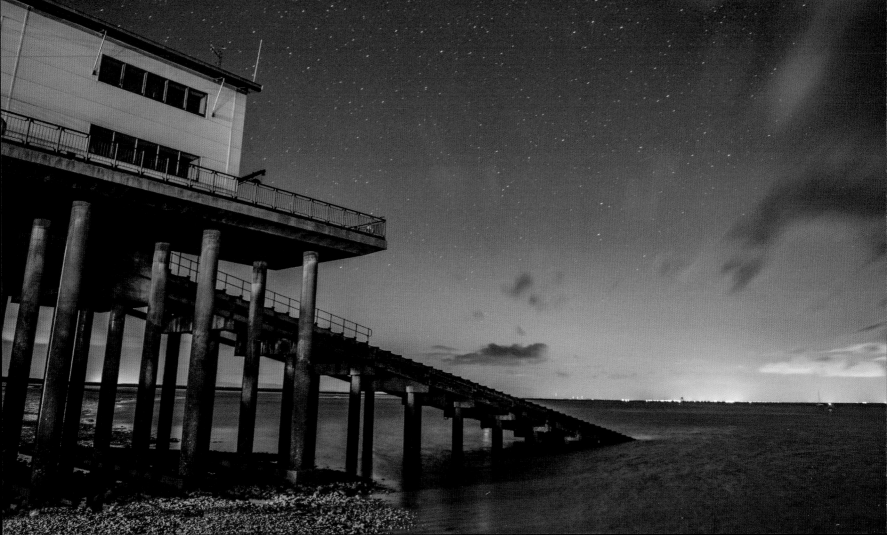

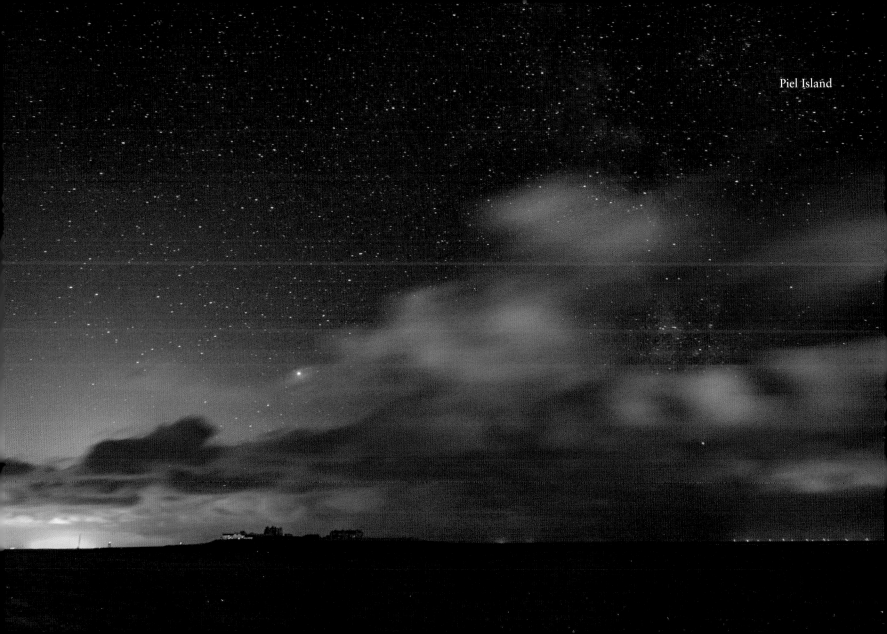

Piel Island

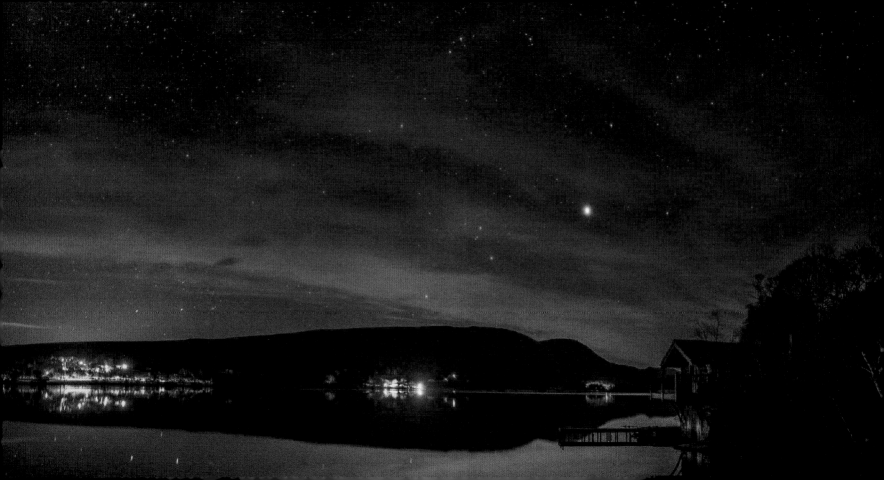

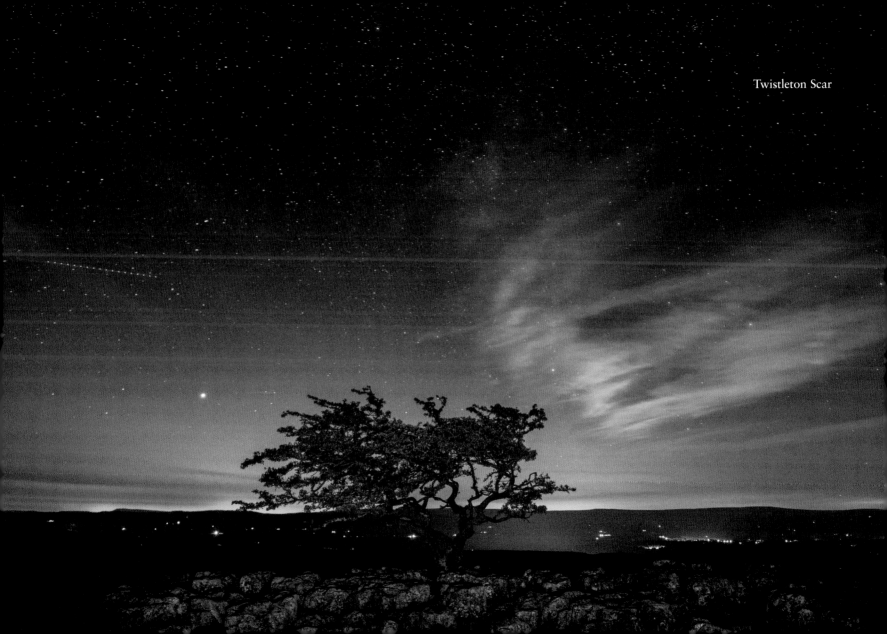

Twistleton Scar

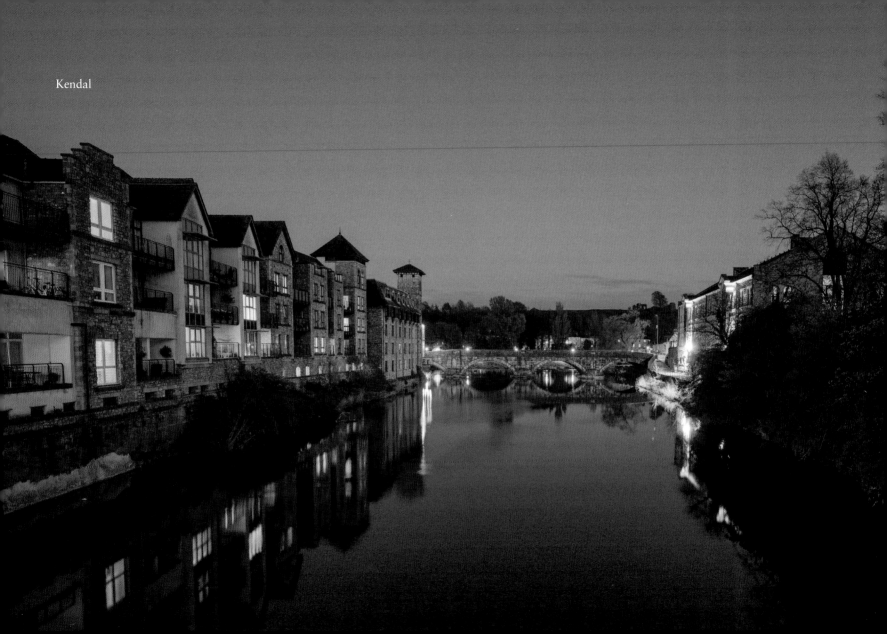

Kendal

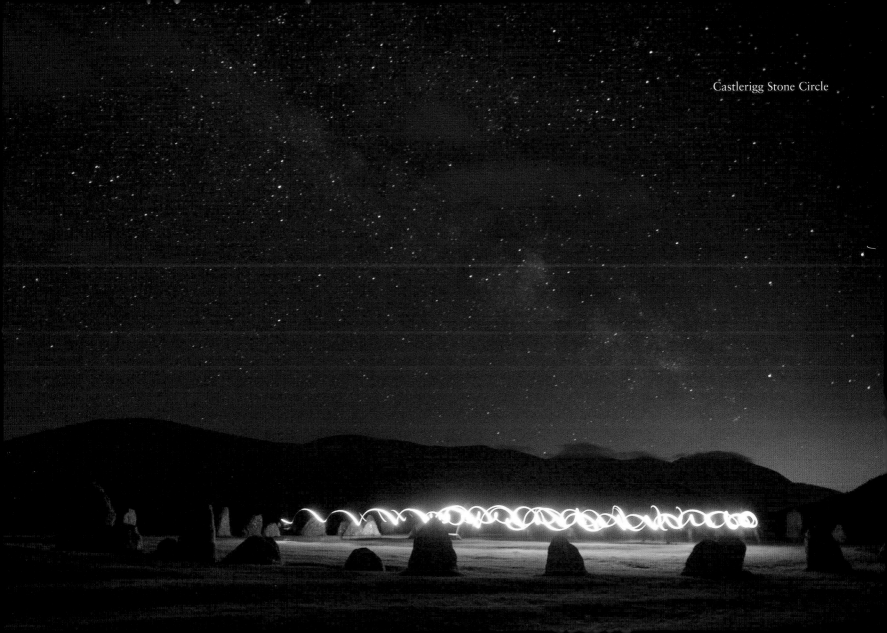

Castlerigg Stone Circle

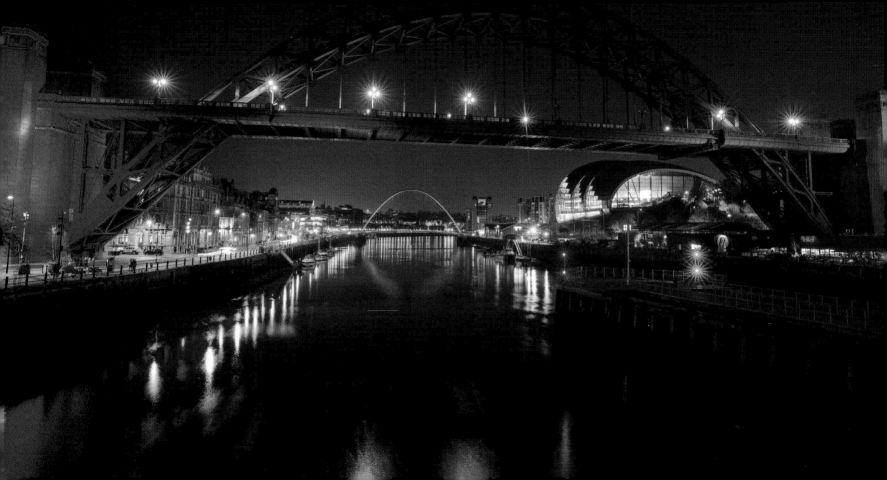

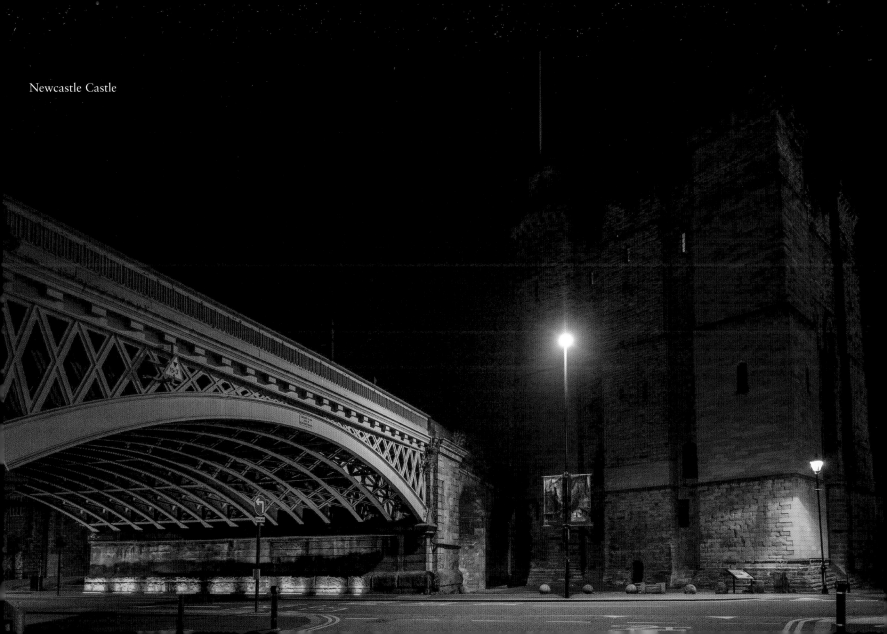
Newcastle Castle

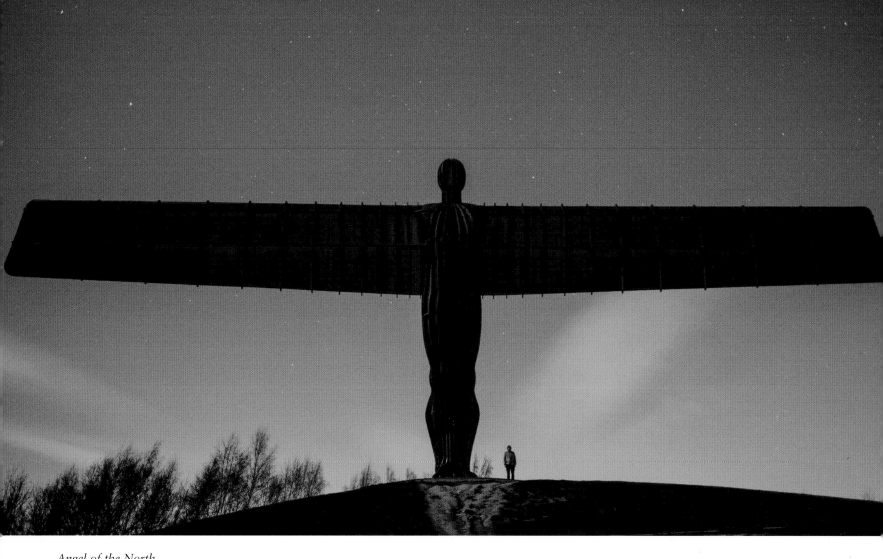

Angel of the North

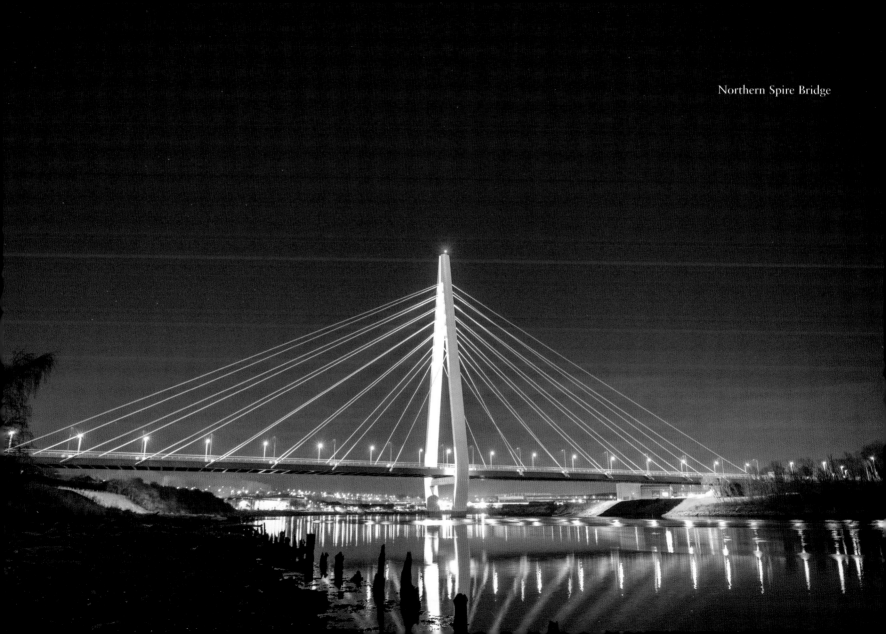

Northern Spire Bridge

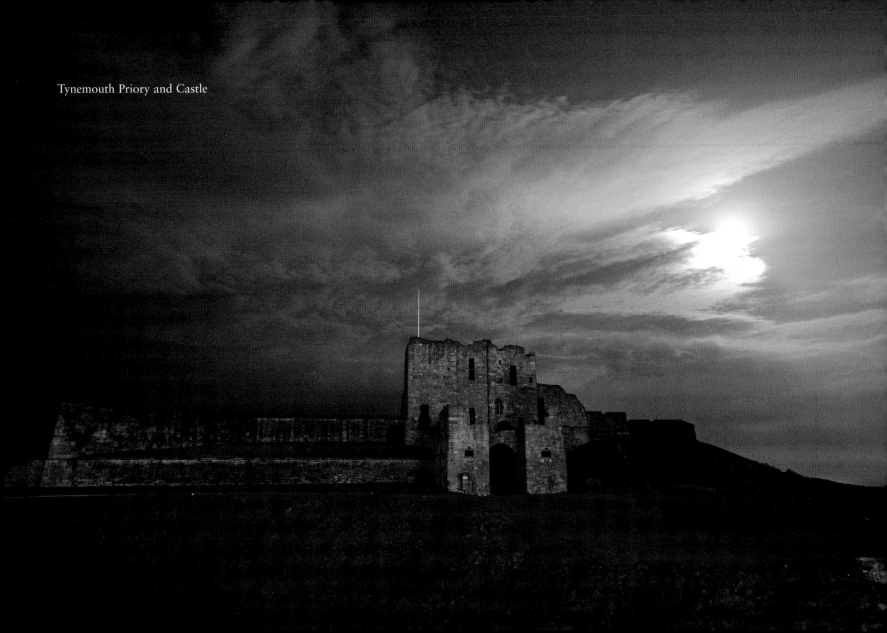

Tynemouth Priory and Castle

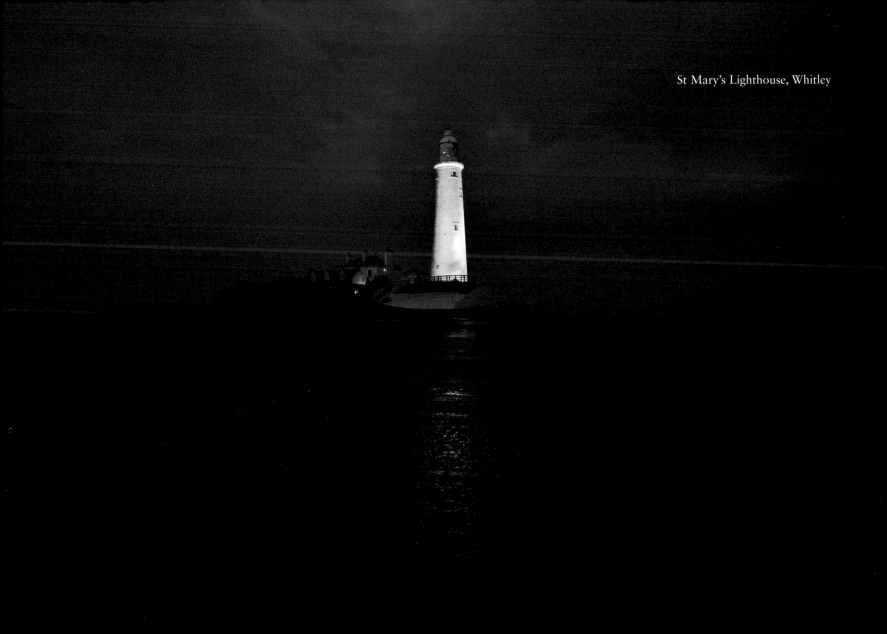

St Mary's Lighthouse, Whitley

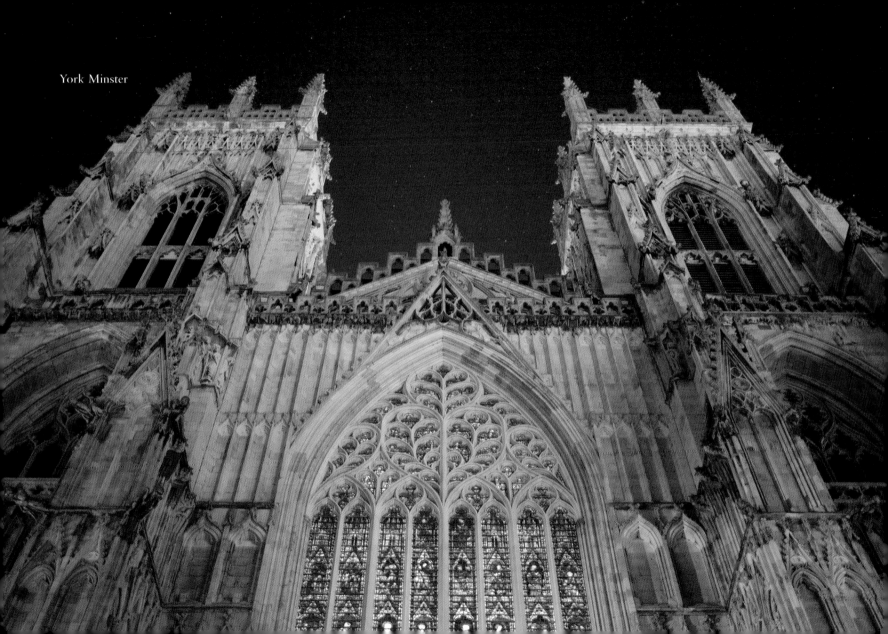
York Minster

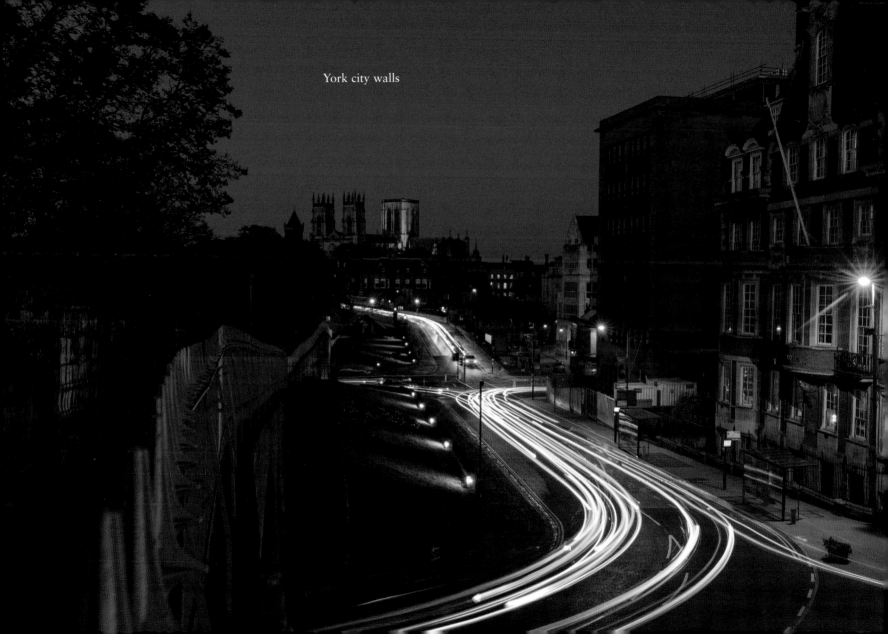

York city walls

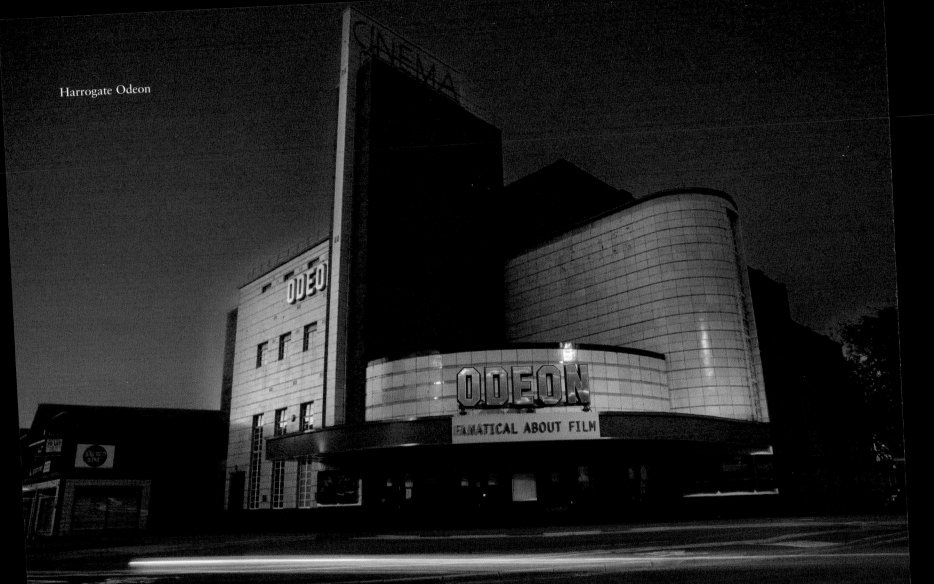

Harrogate Odeon

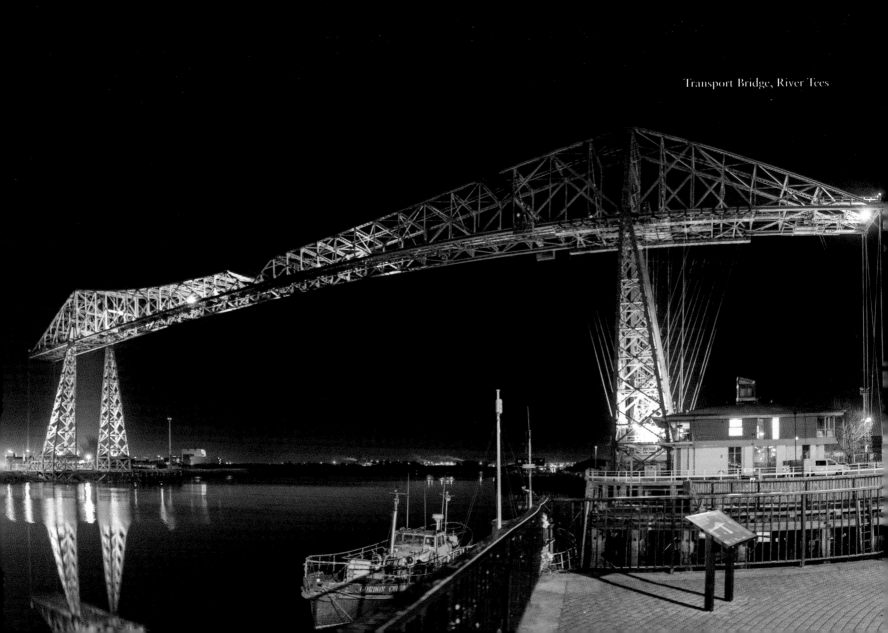

Transport Bridge, River Tees

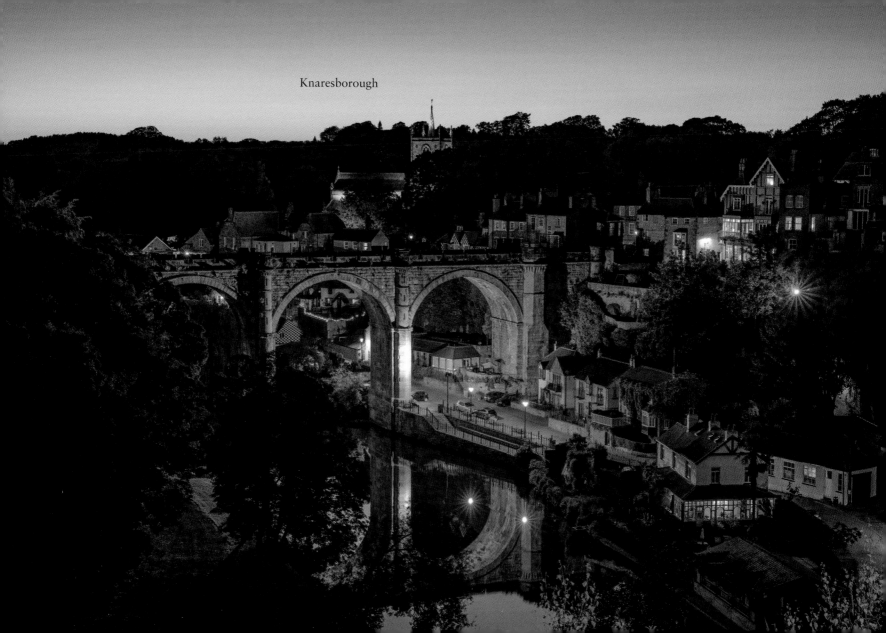

Knaresborough

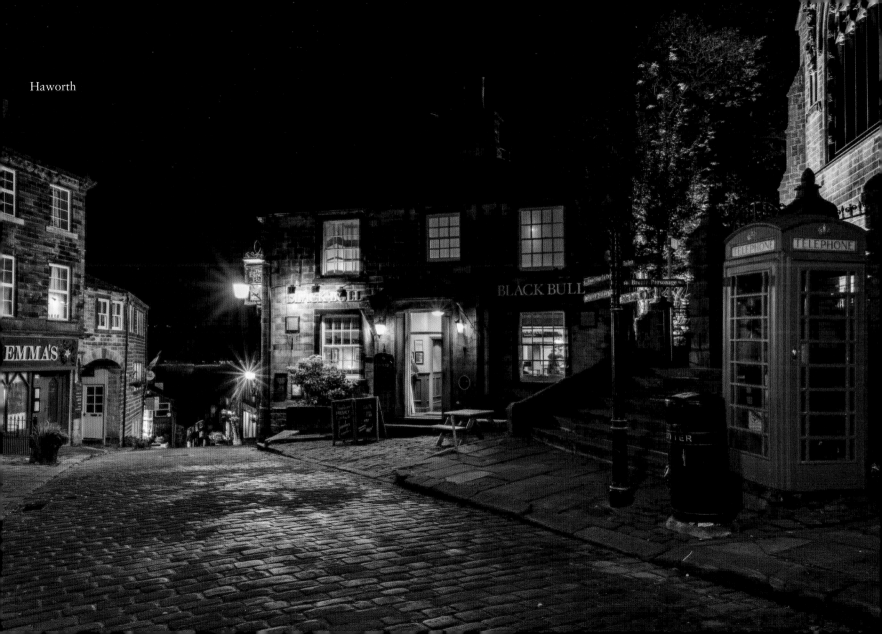

Haworth

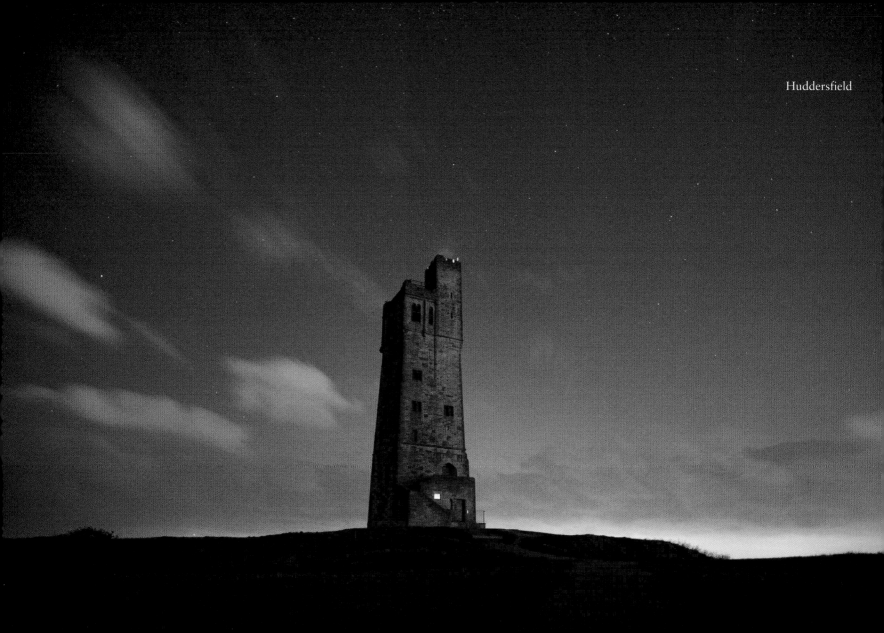
Huddersfield

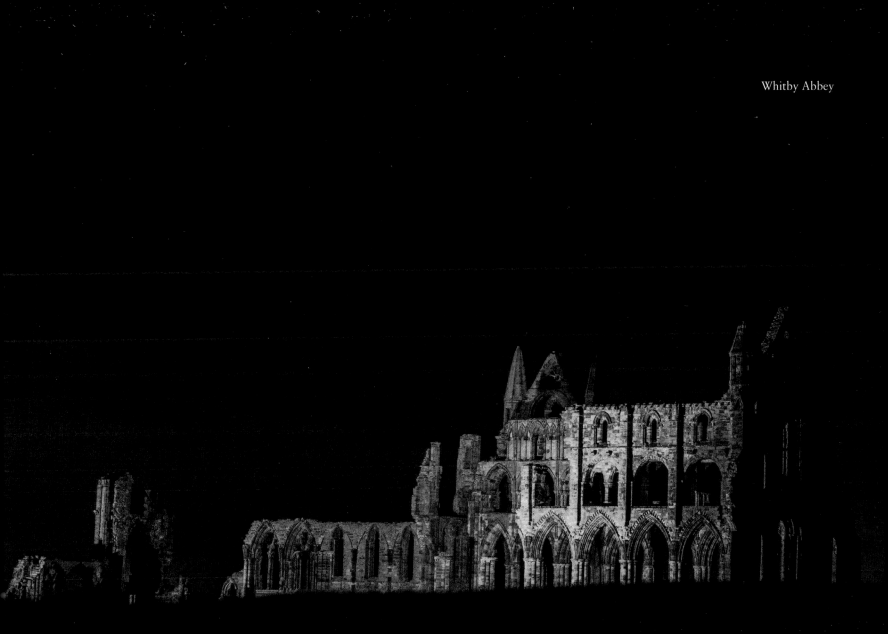

Whitby Abbey

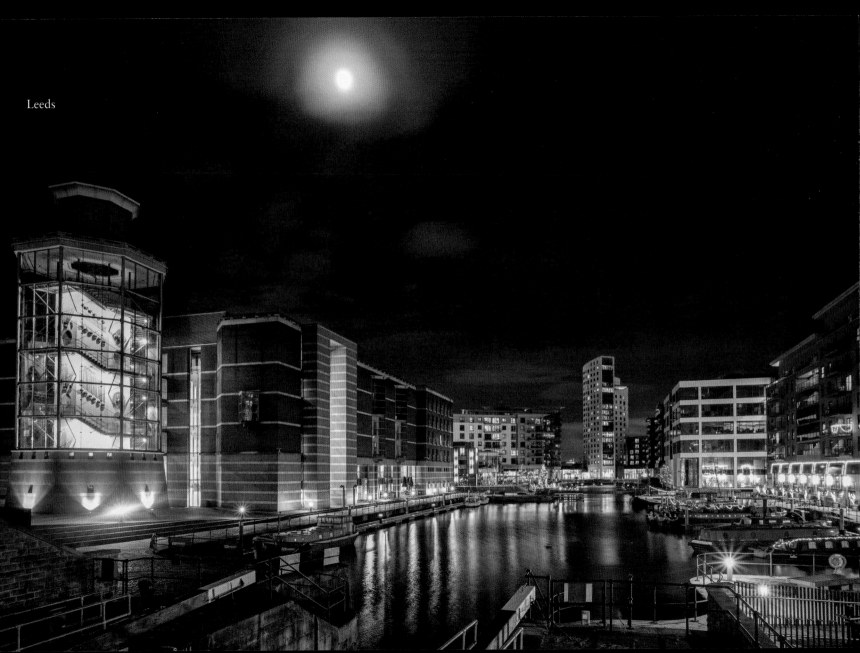

Leeds

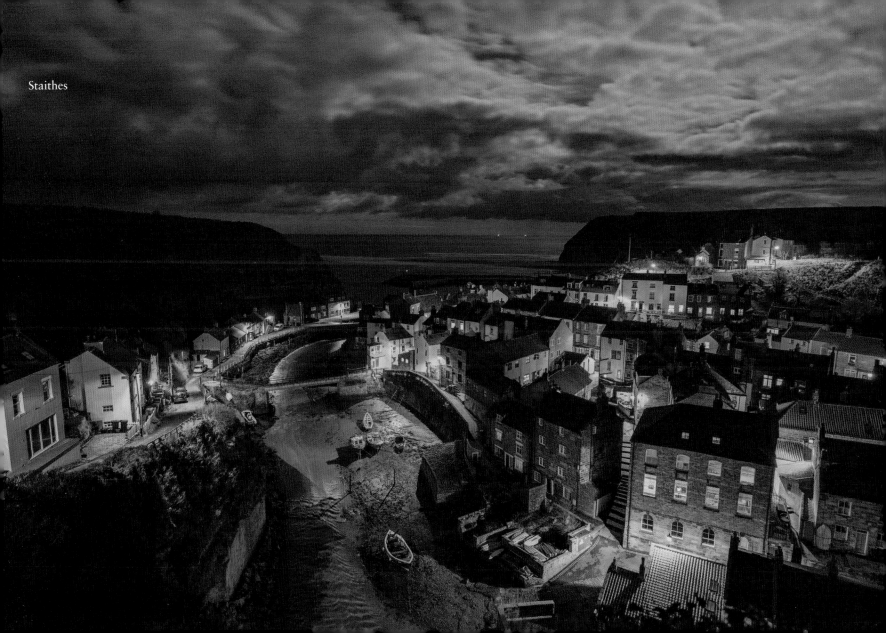

Staithes

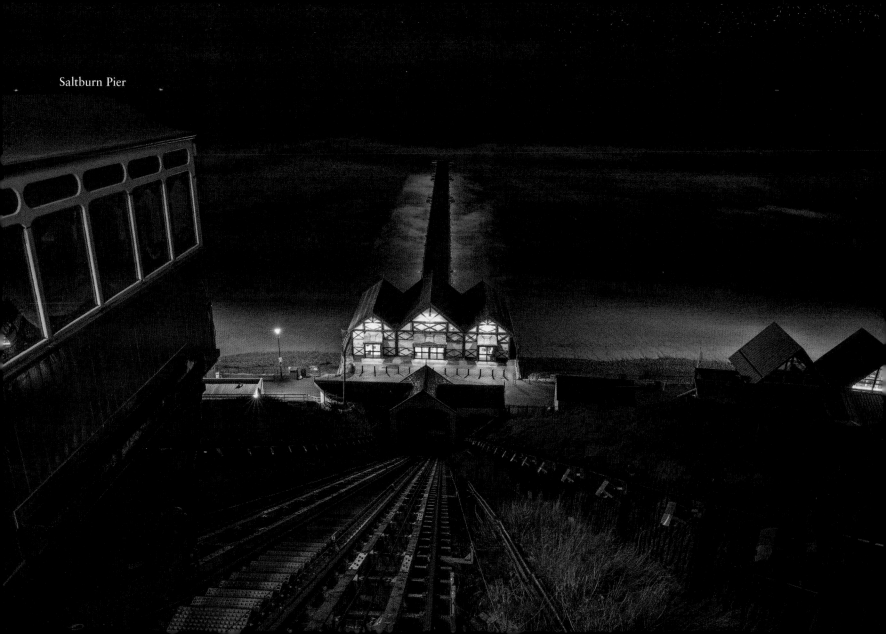

Saltburn Pier

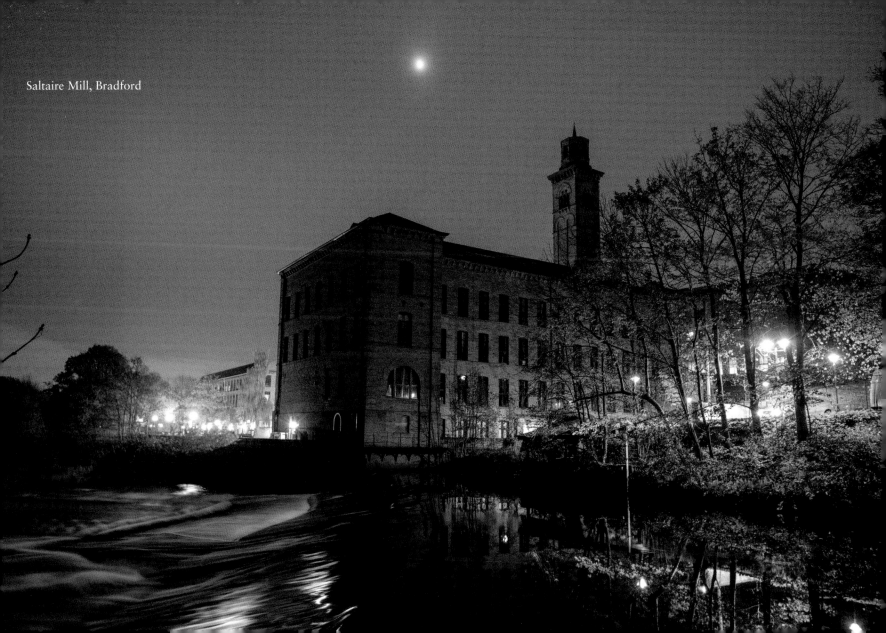

Saltaire Mill, Bradford

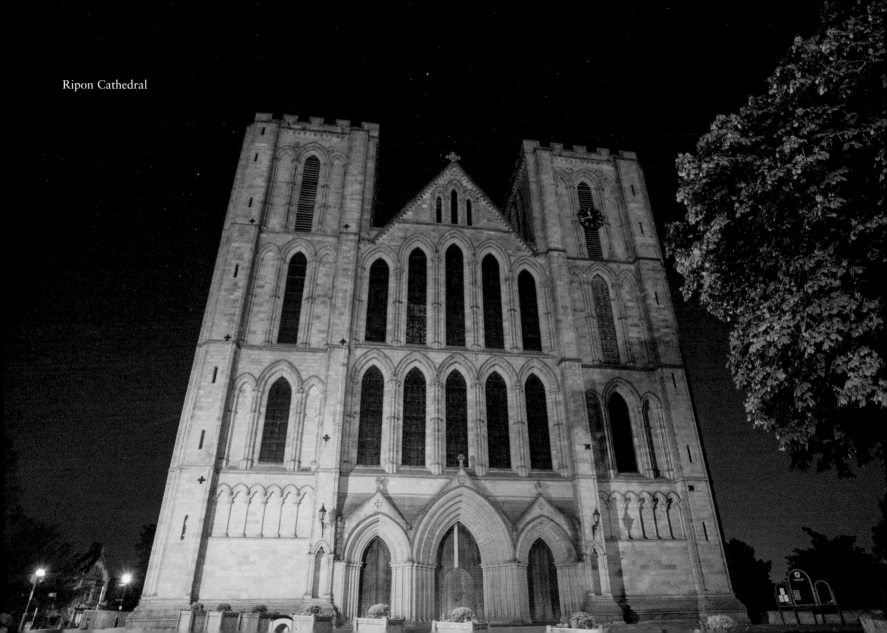

Ripon Cathedral

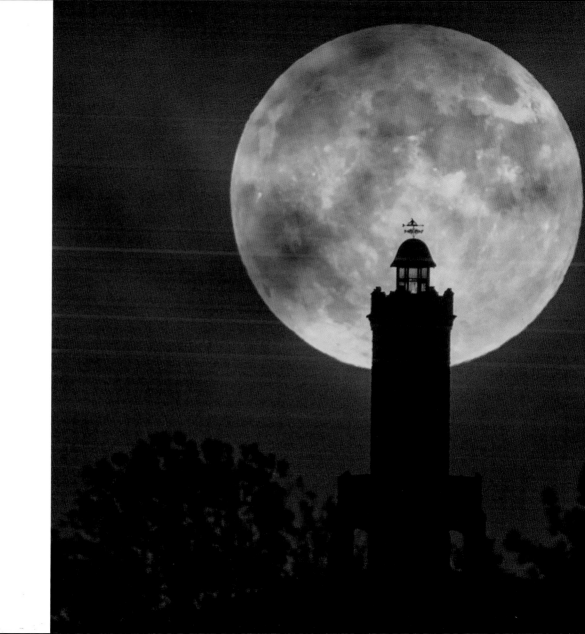

Darwen Tower

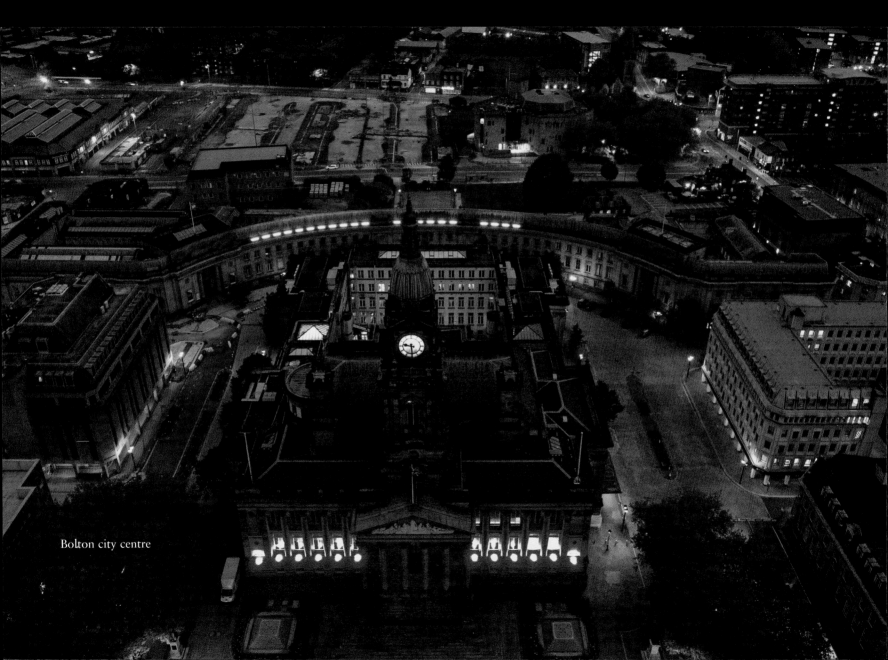

Bolton city centre

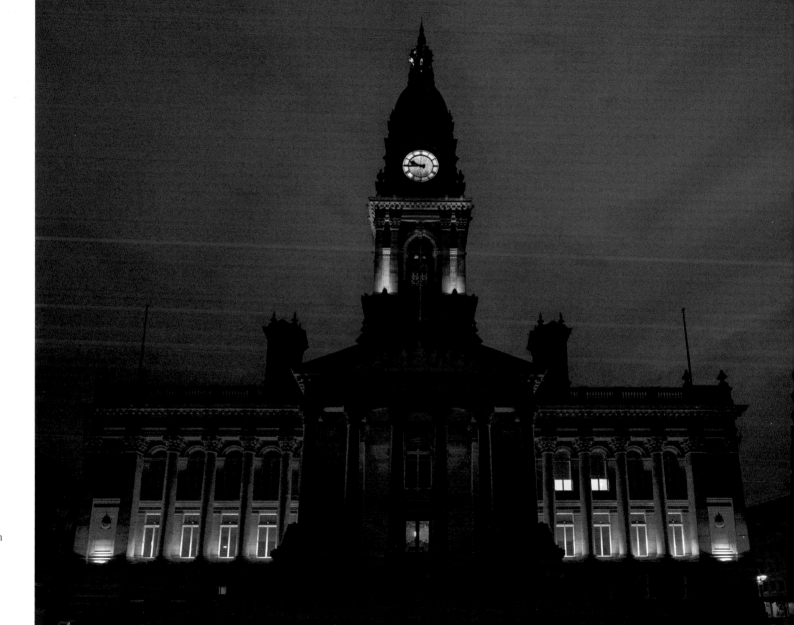

Bolton Town
Hall

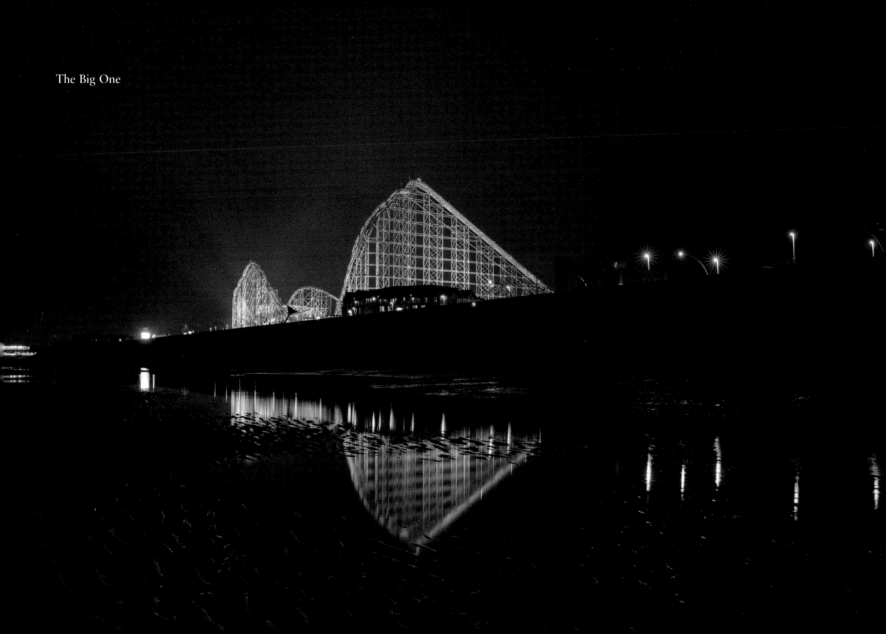

The Big One

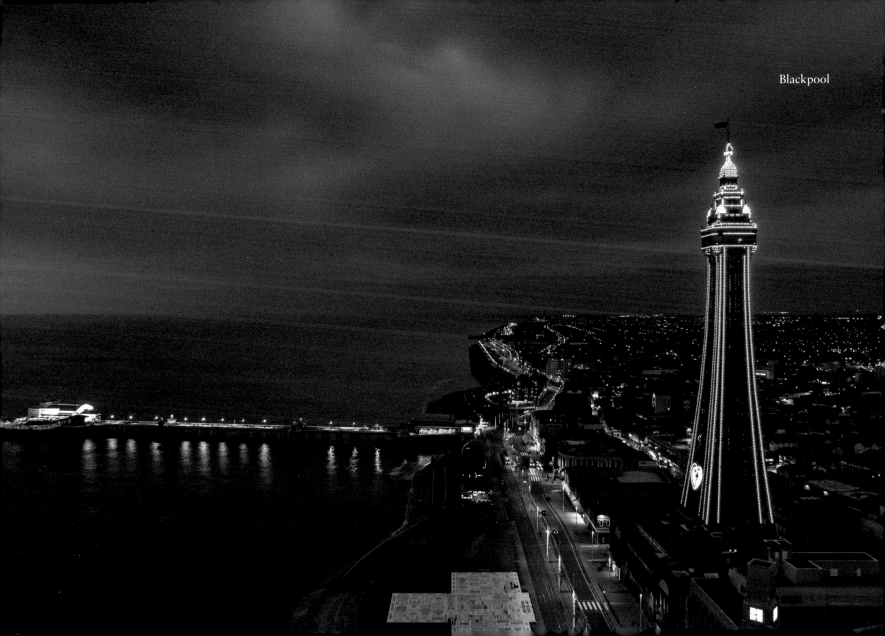

Blackpool

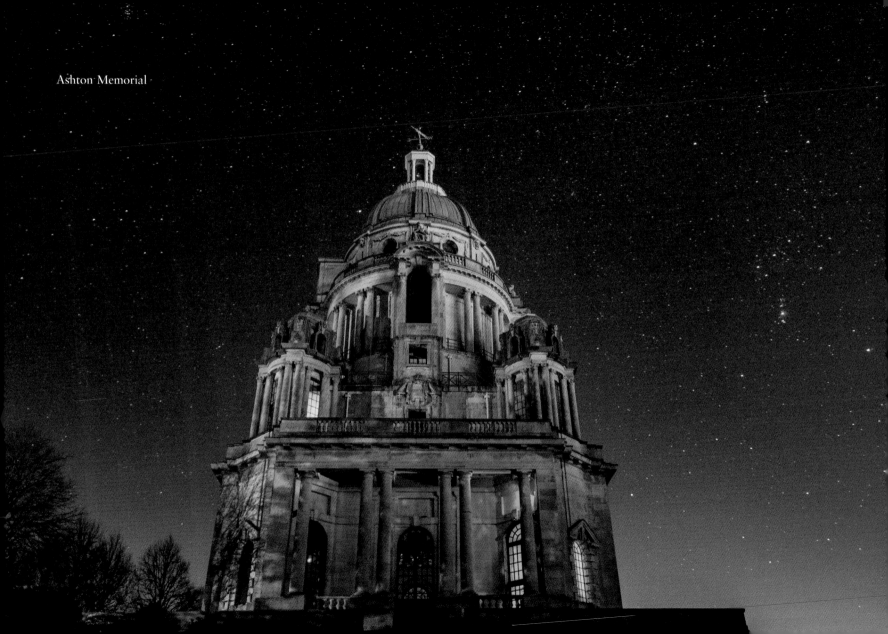

Ashton Memorial

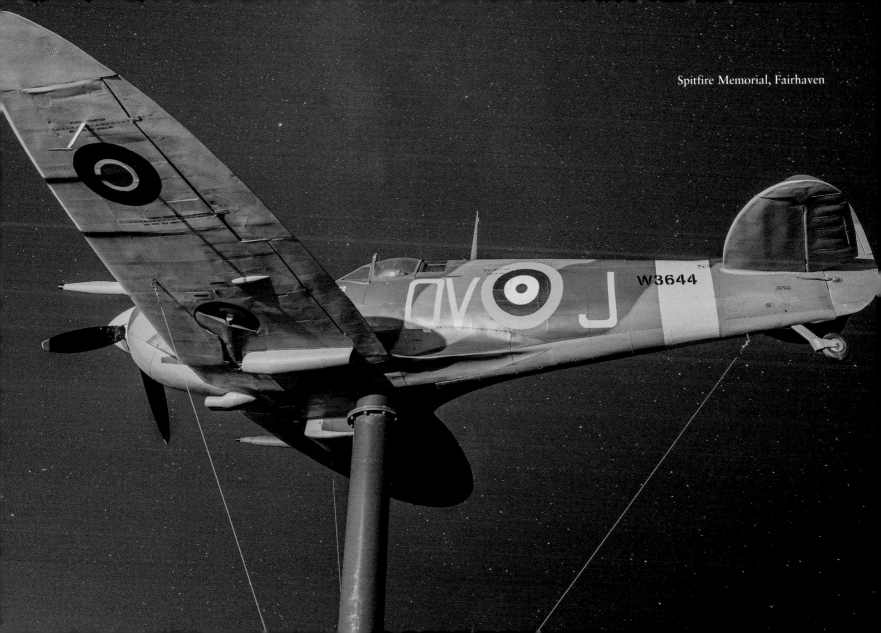

Spitfire Memorial, Fairhaven

W3644

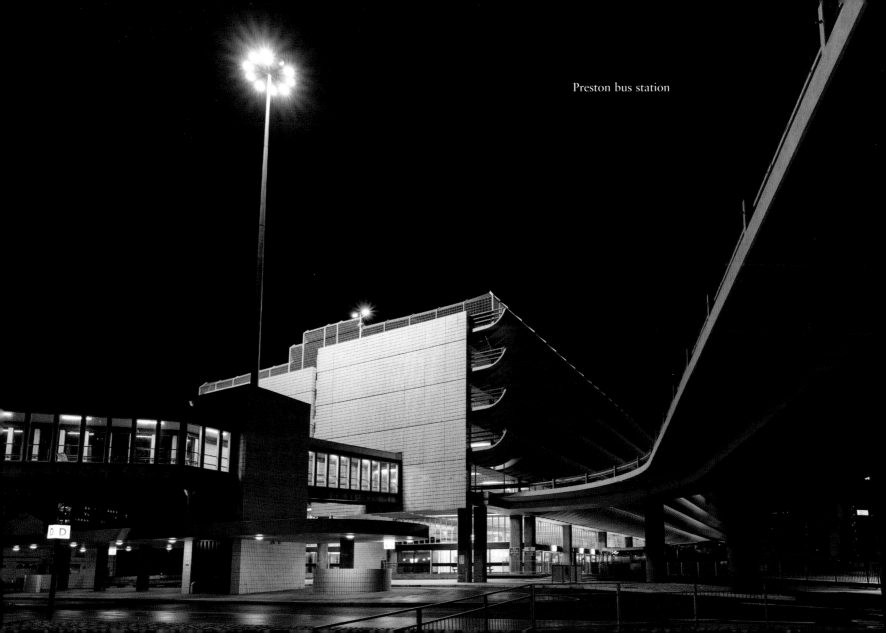

Preston bus station

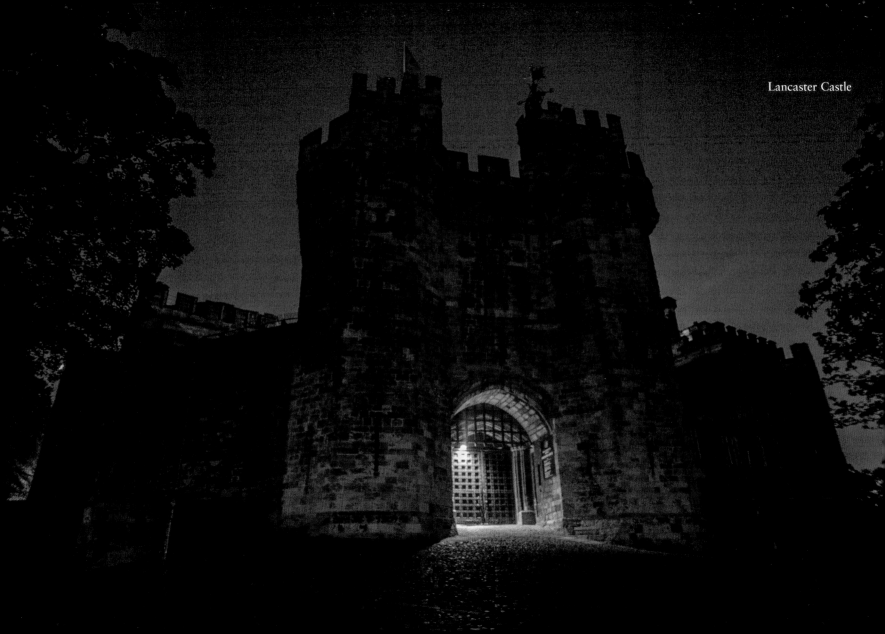

Lancaster Castle

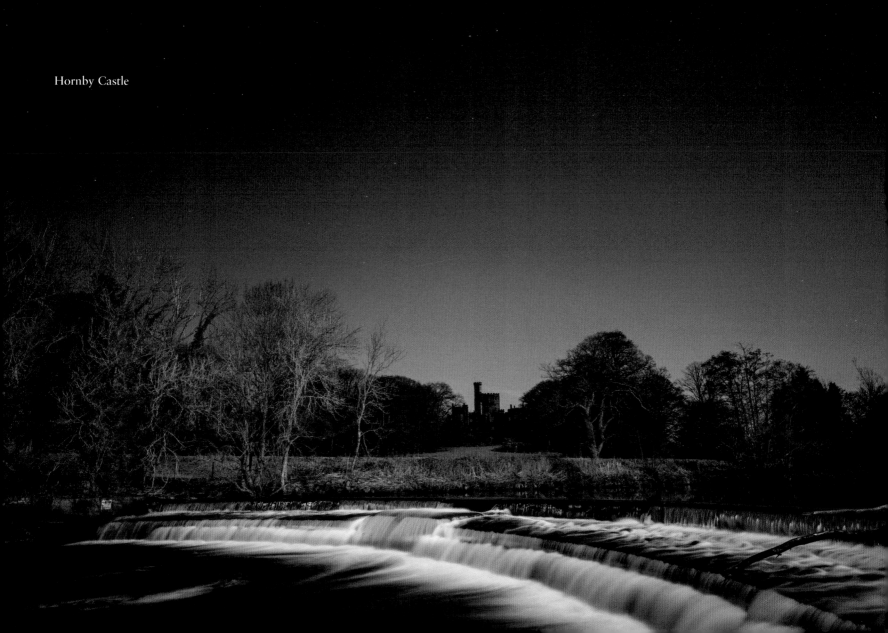

Hornby Castle

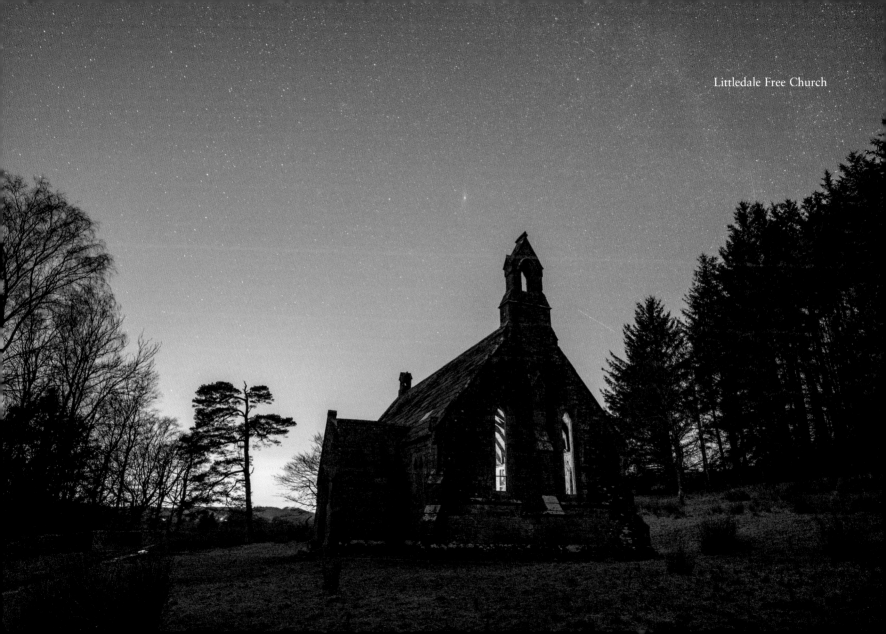

Littledale Free Church

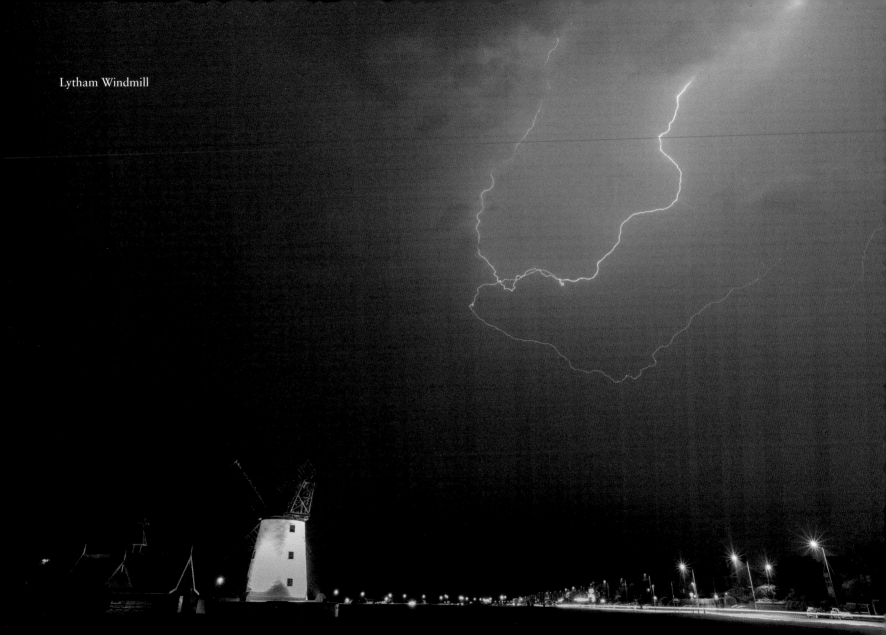

Lytham Windmill

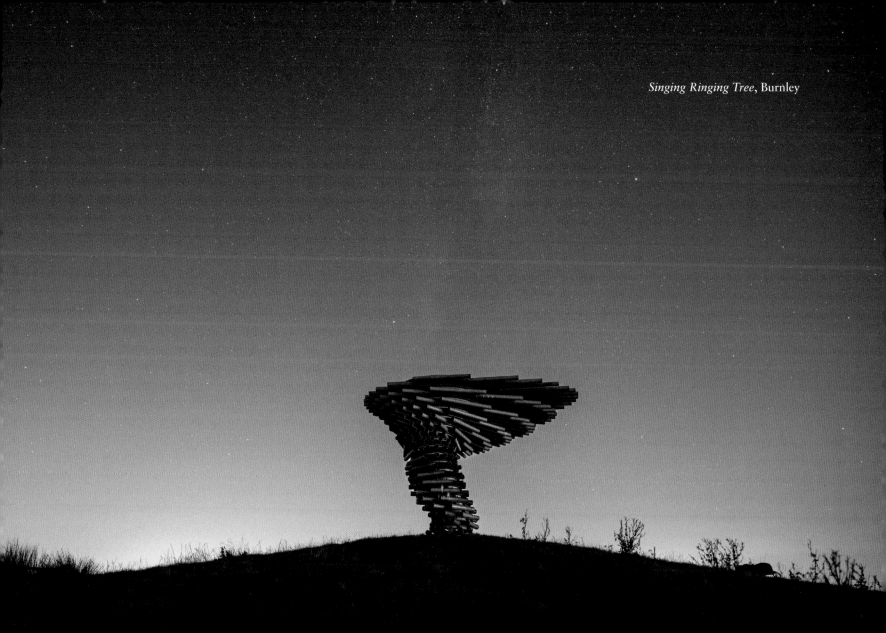

Singing Ringing Tree, Burnley

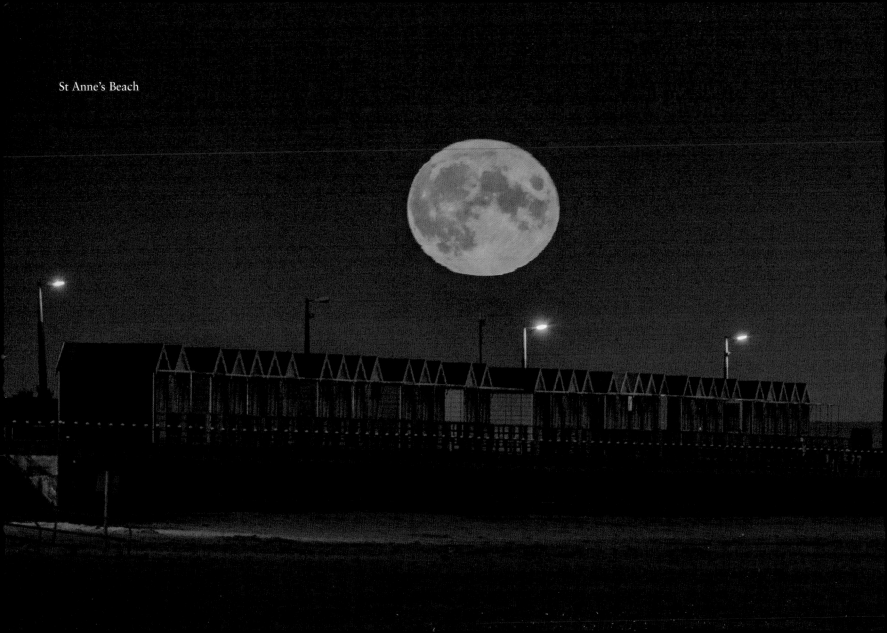

St Anne's Beach

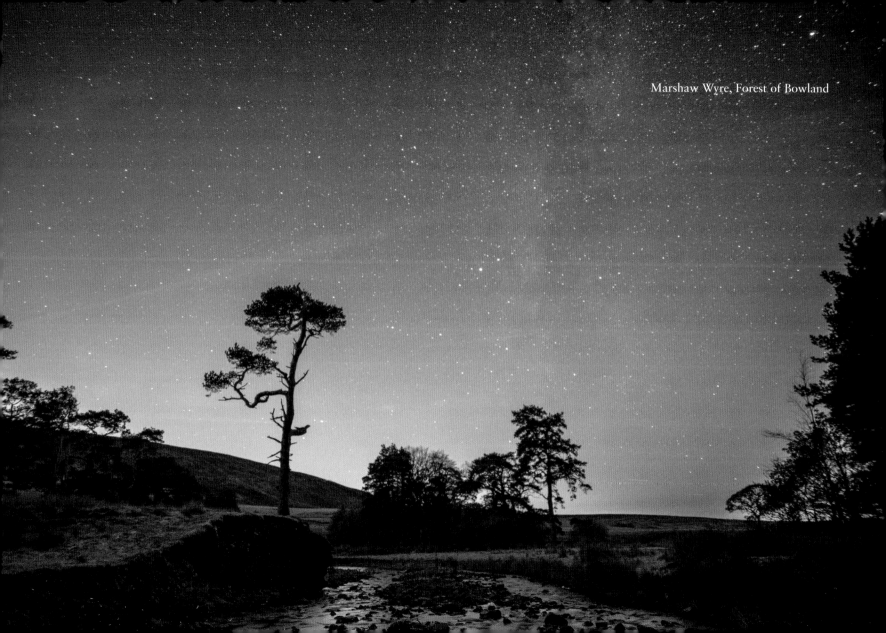

Marshaw Wyre, Forest of Bowland

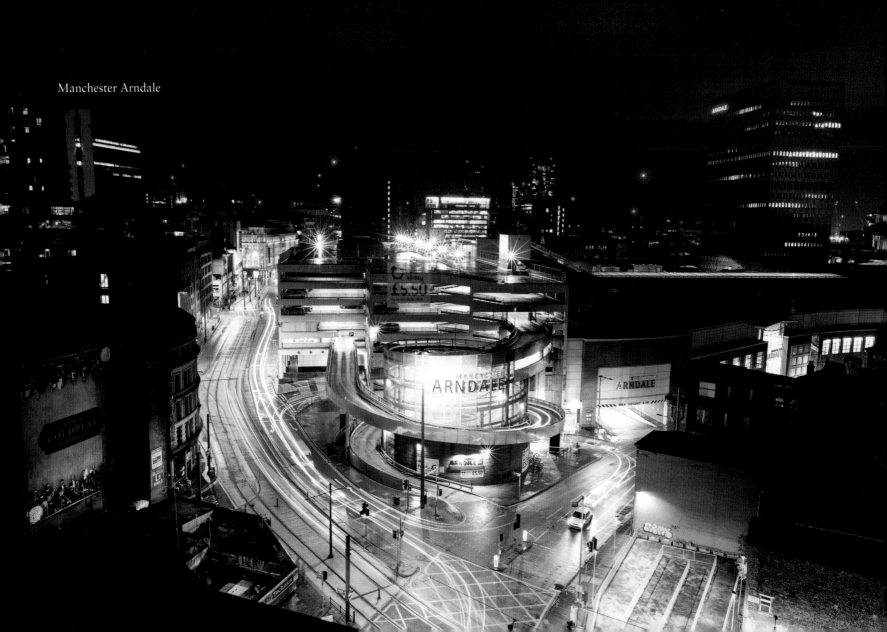

Manchester Arndale

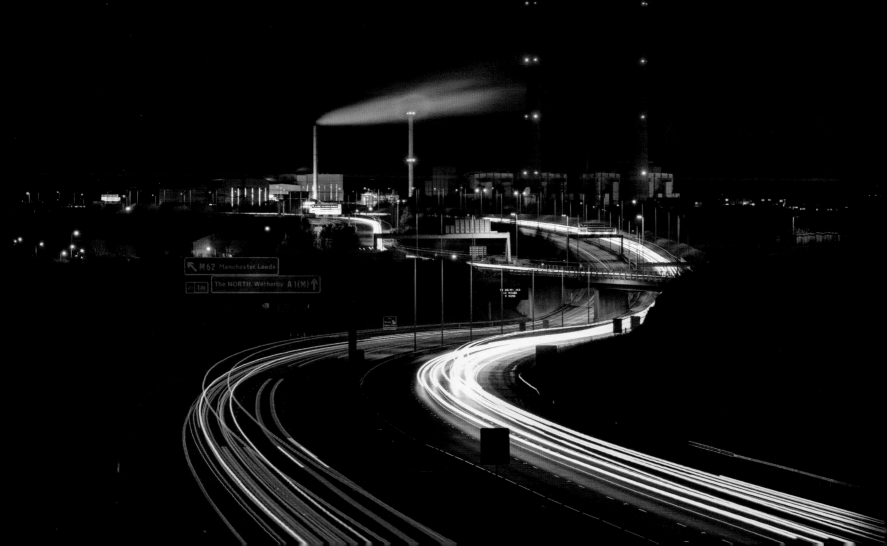

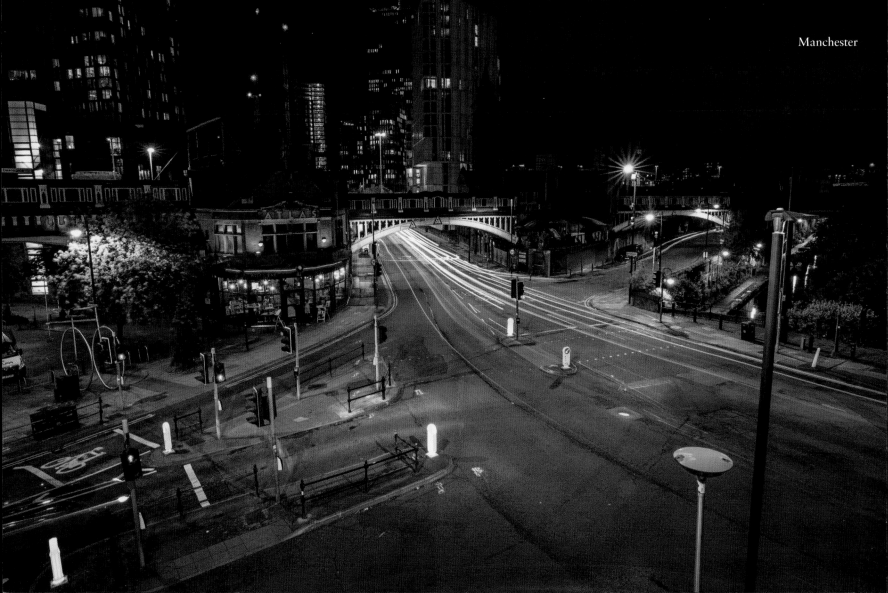

Manchester

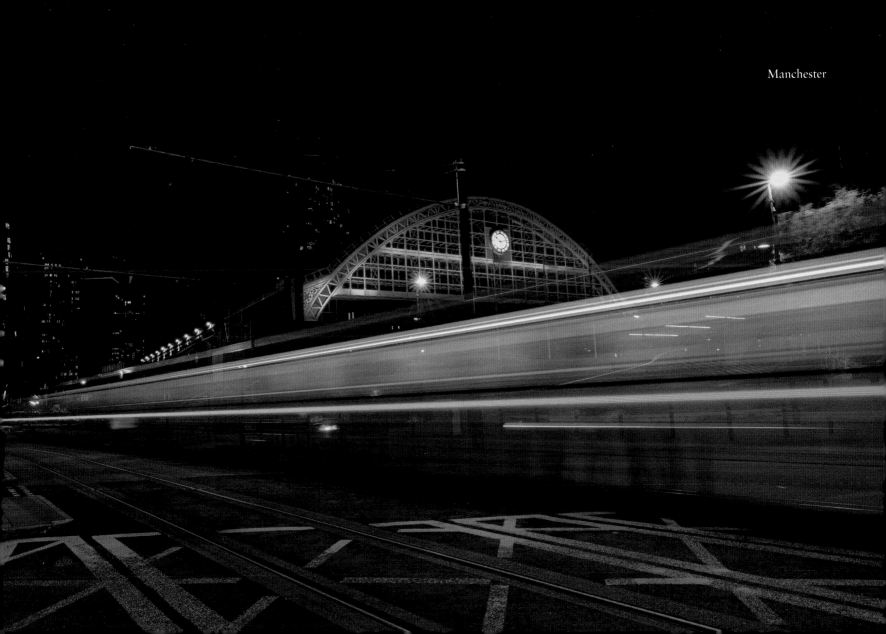

Manchester

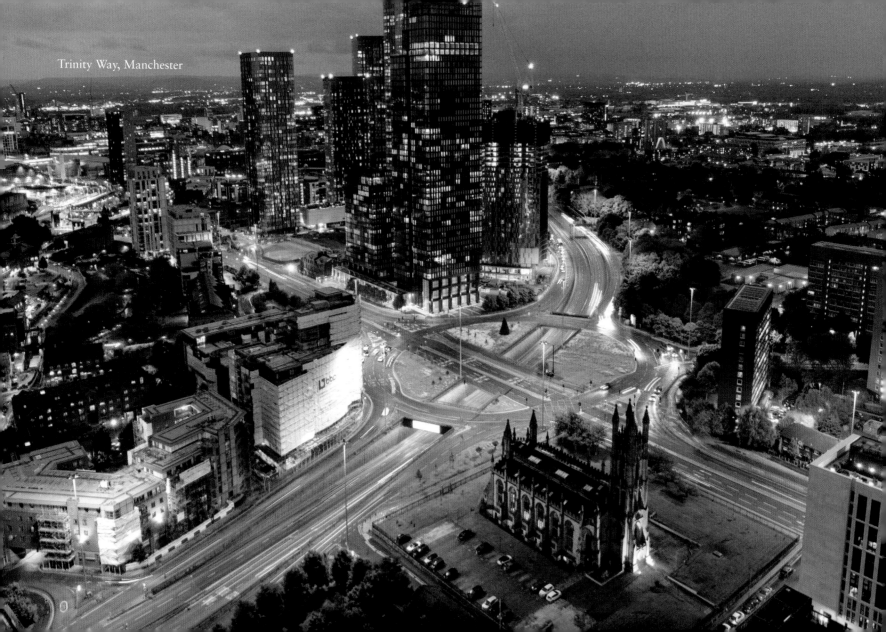
Trinity Way, Manchester

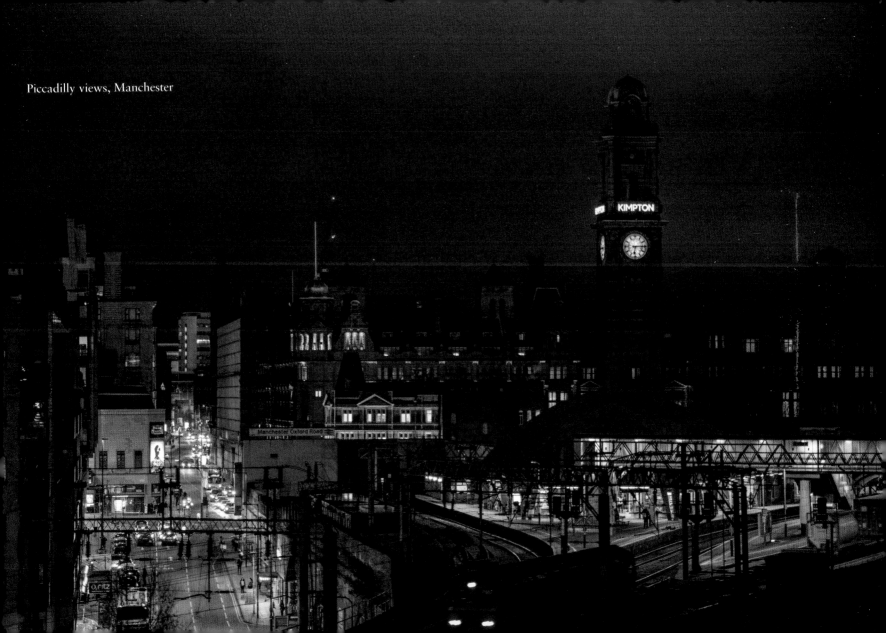

Piccadilly views, Manchester

Stockport Plaza

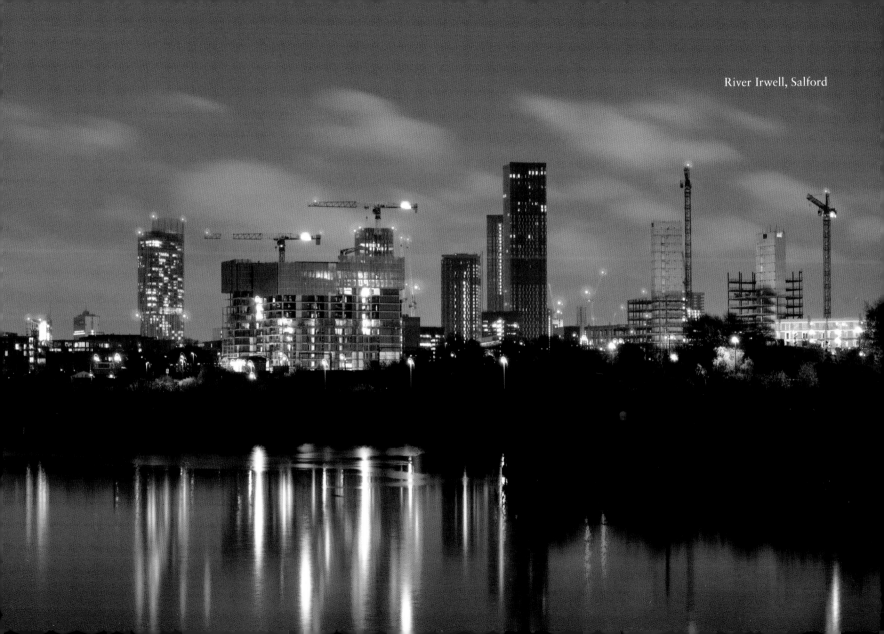
River Irwell, Salford

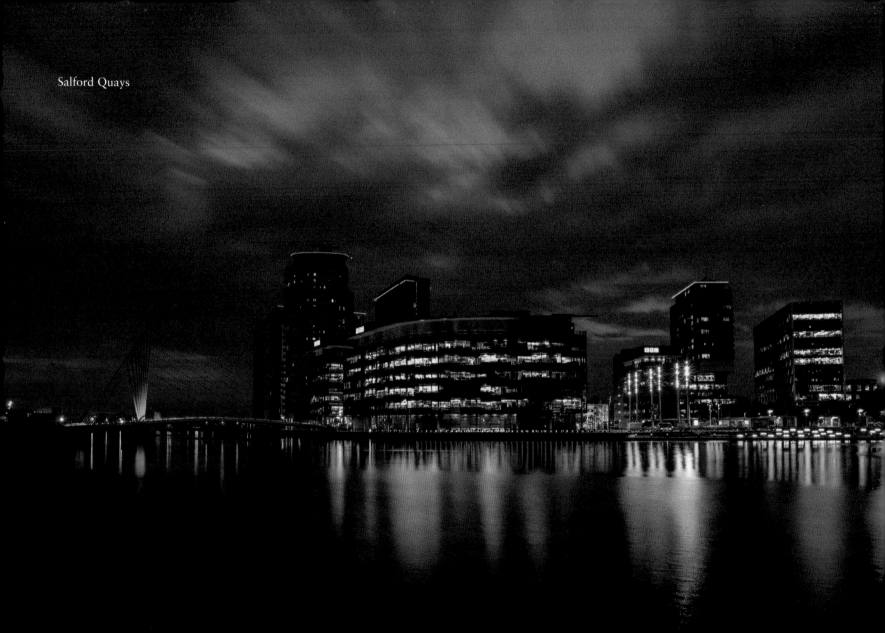
Salford Quays

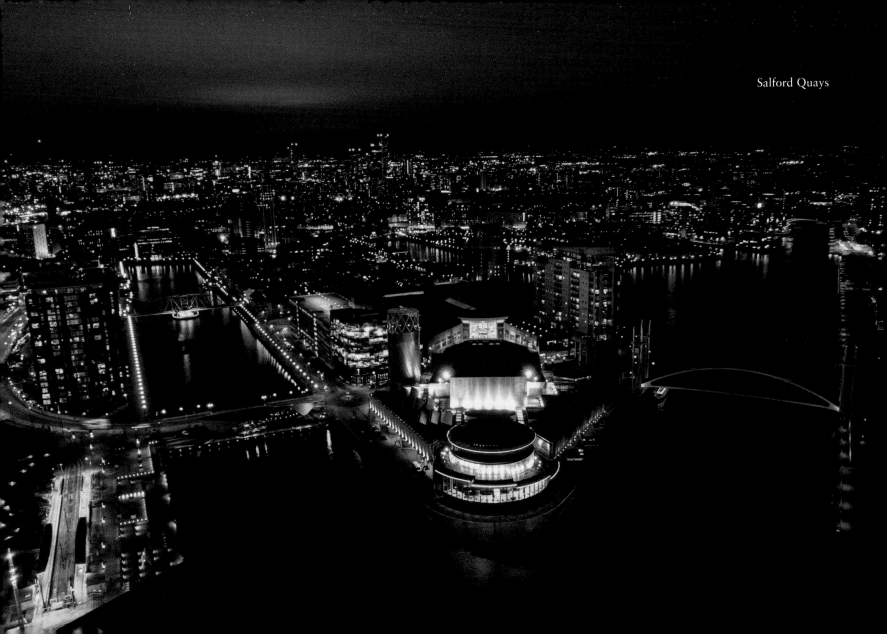

Salford Quays

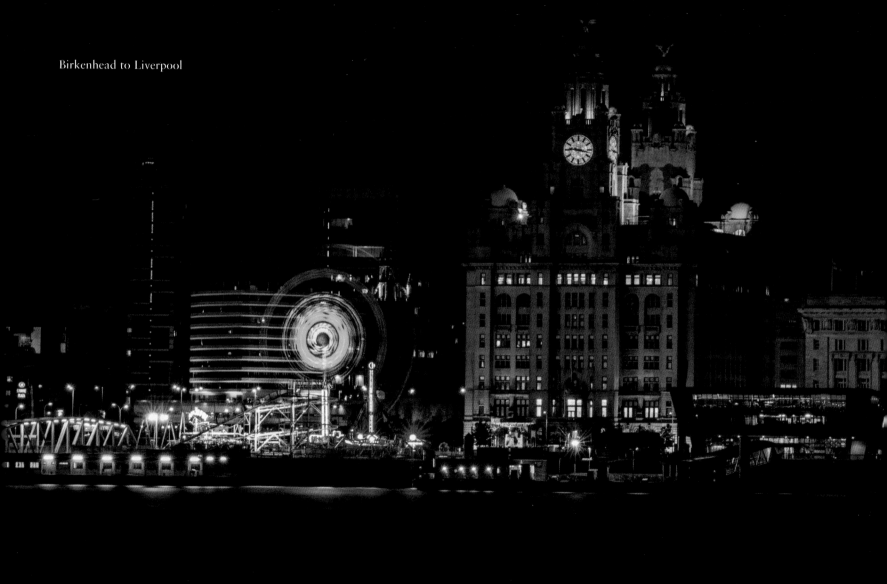

Birkenhead to Liverpool

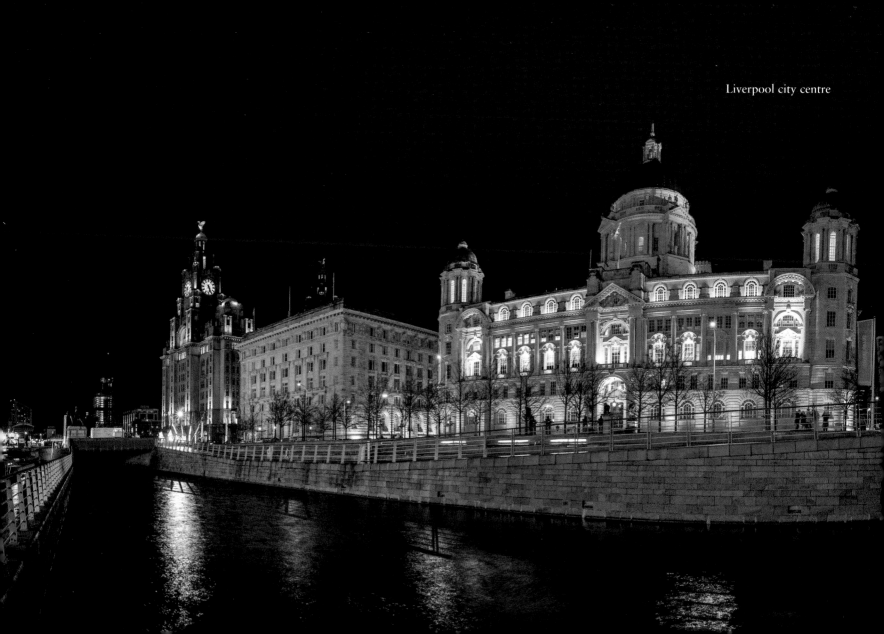

Liverpool city centre

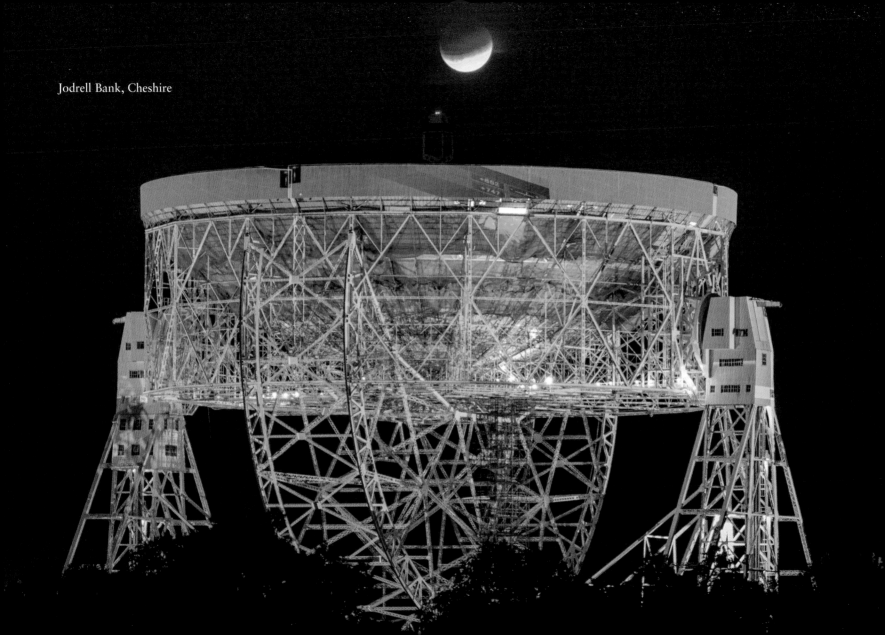

Jodrell Bank, Cheshire

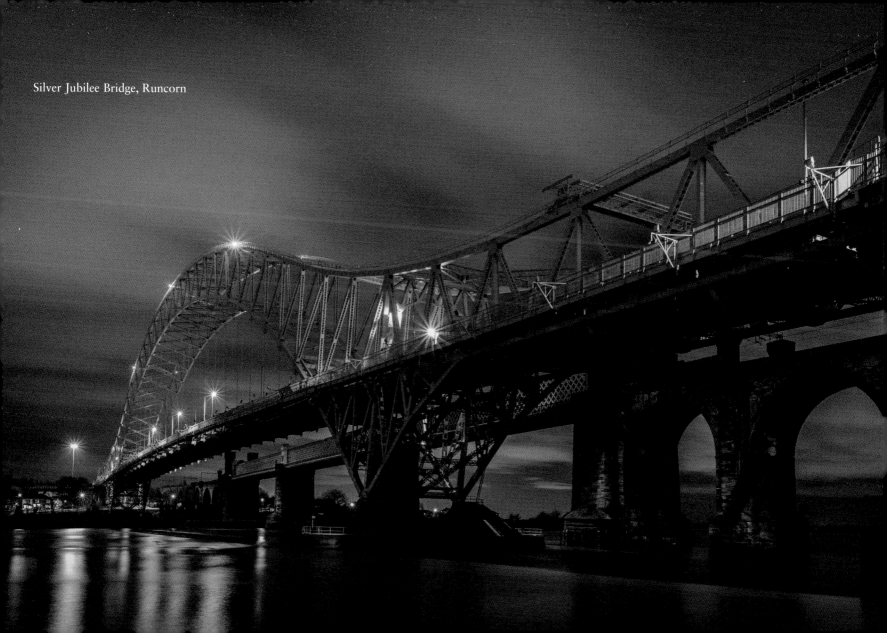

Silver Jubilee Bridge, Runcorn

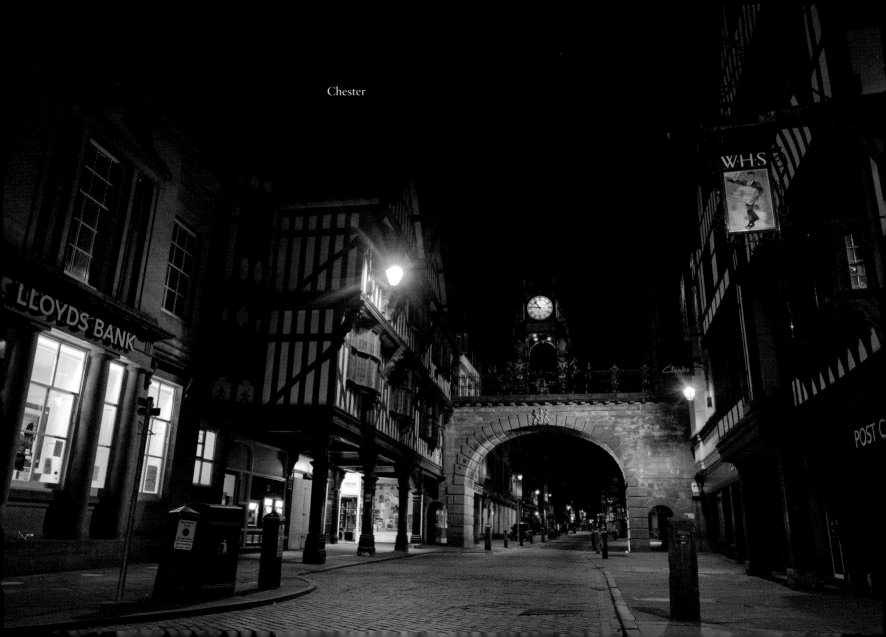

Chester

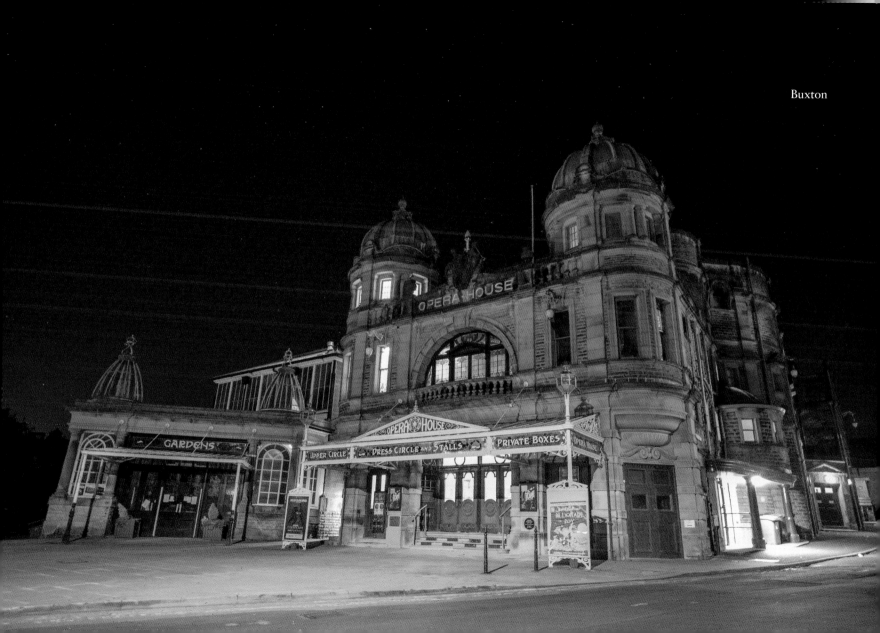

Buxton

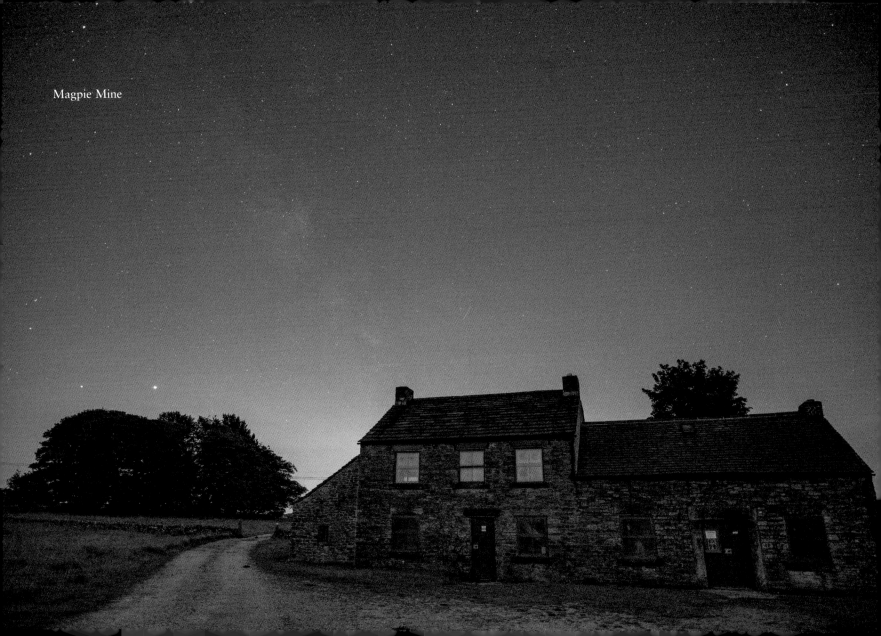

Magpie Mine

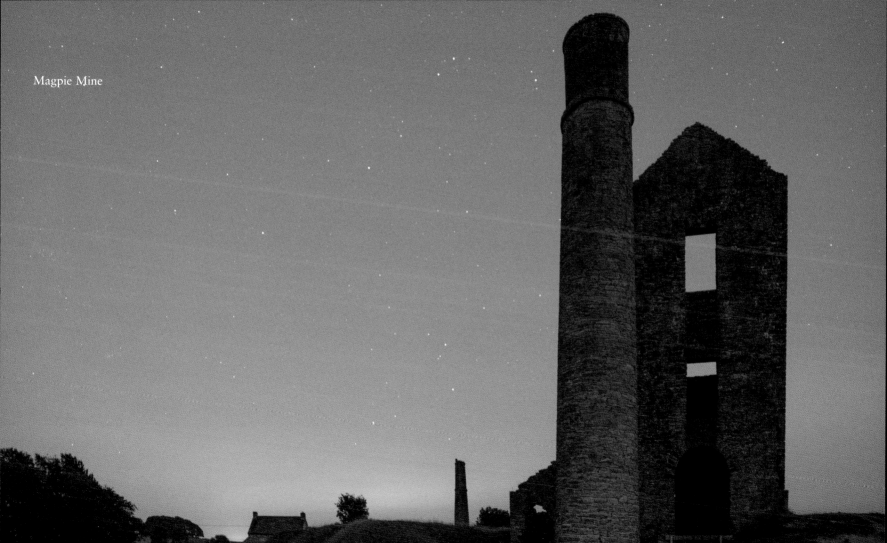

Magpie Mine

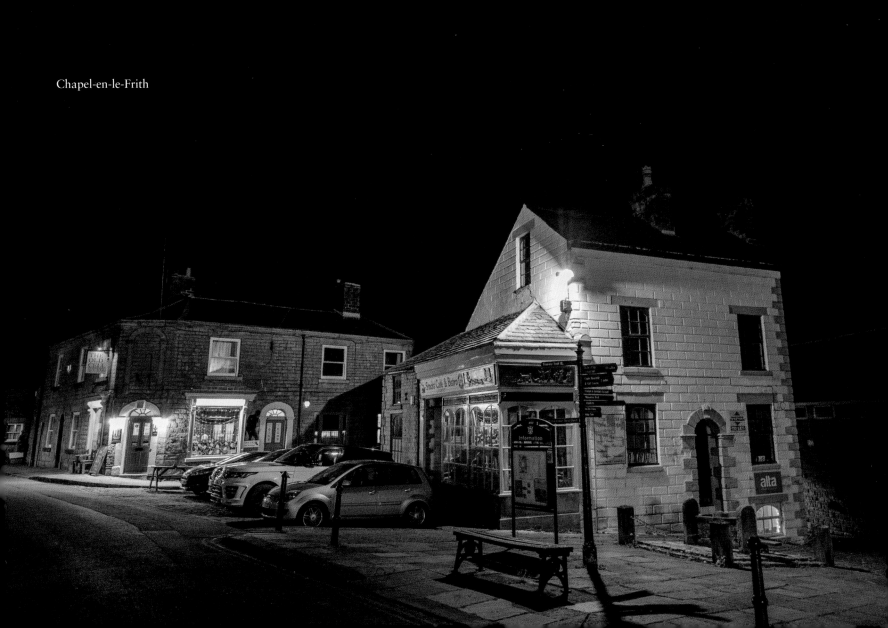

Chapel-en-le-Frith

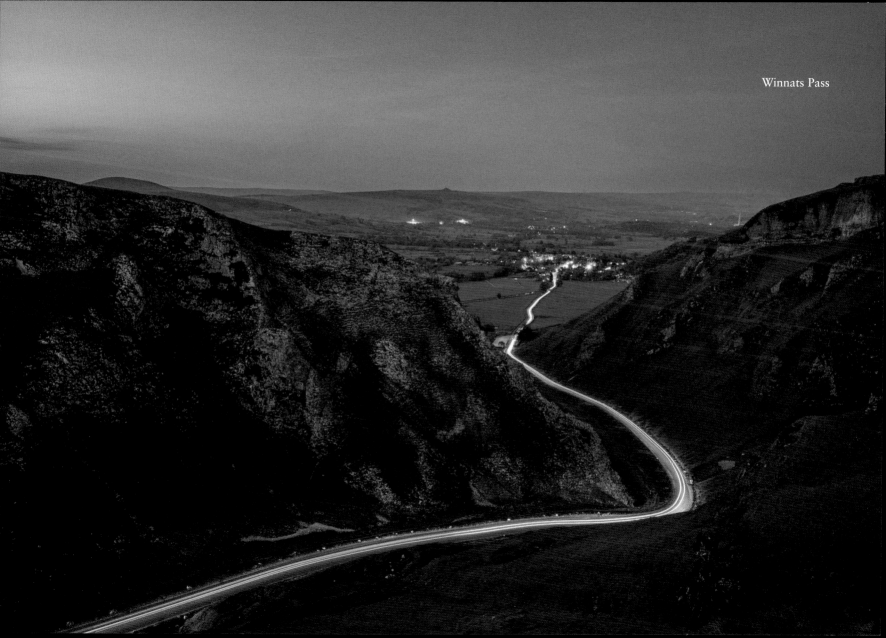

Winnats Pass

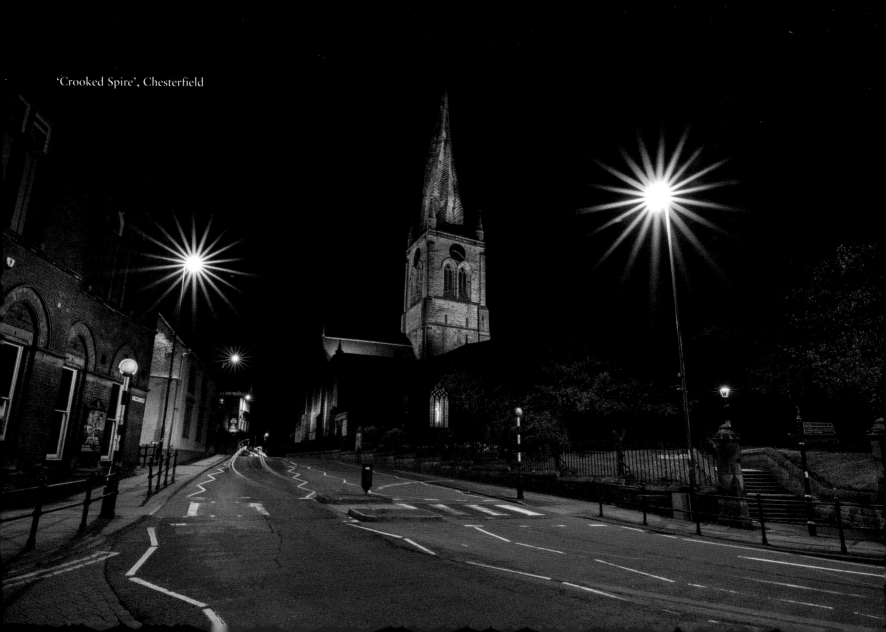

'Crooked Spire', Chesterfield

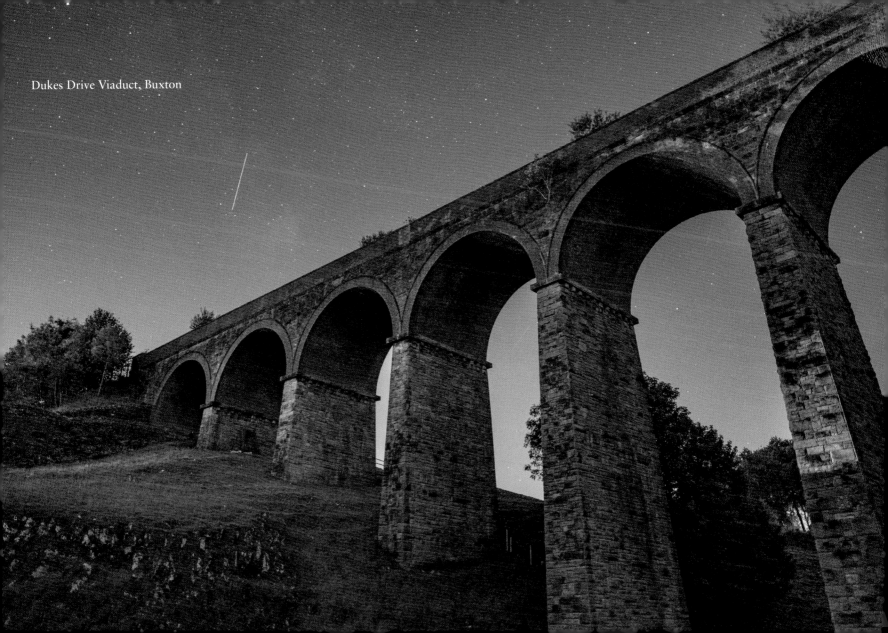

Dukes Drive Viaduct, Buxton

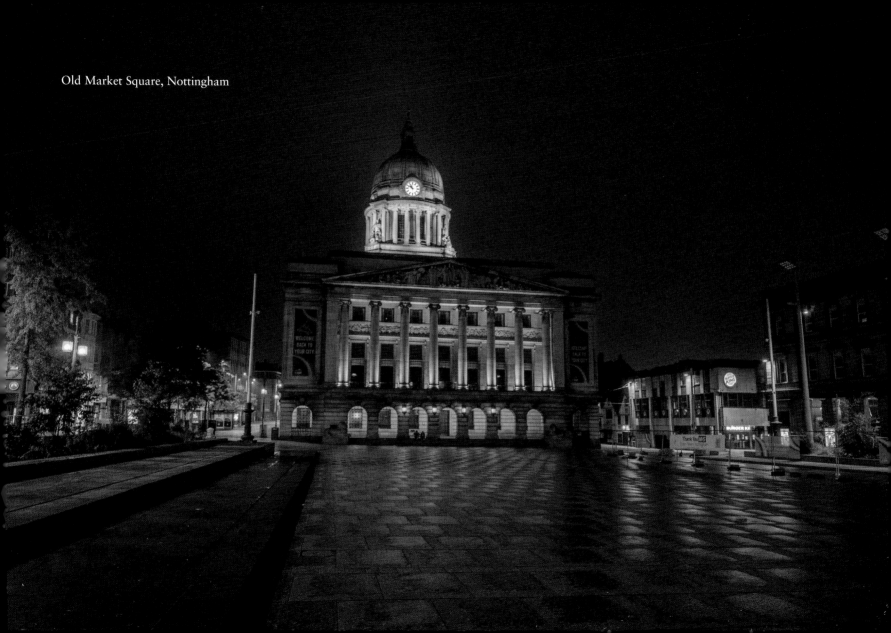

Old Market Square, Nottingham

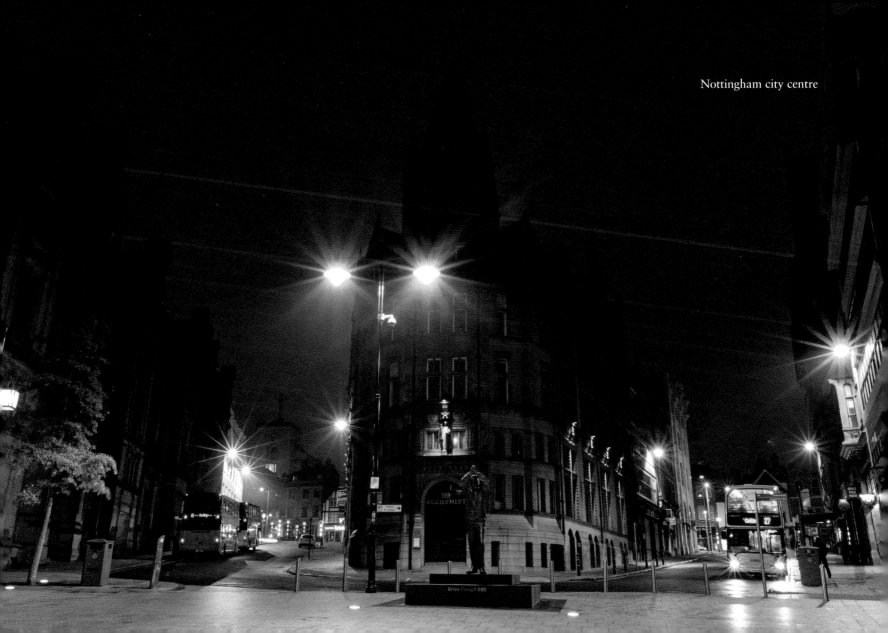
Nottingham city centre

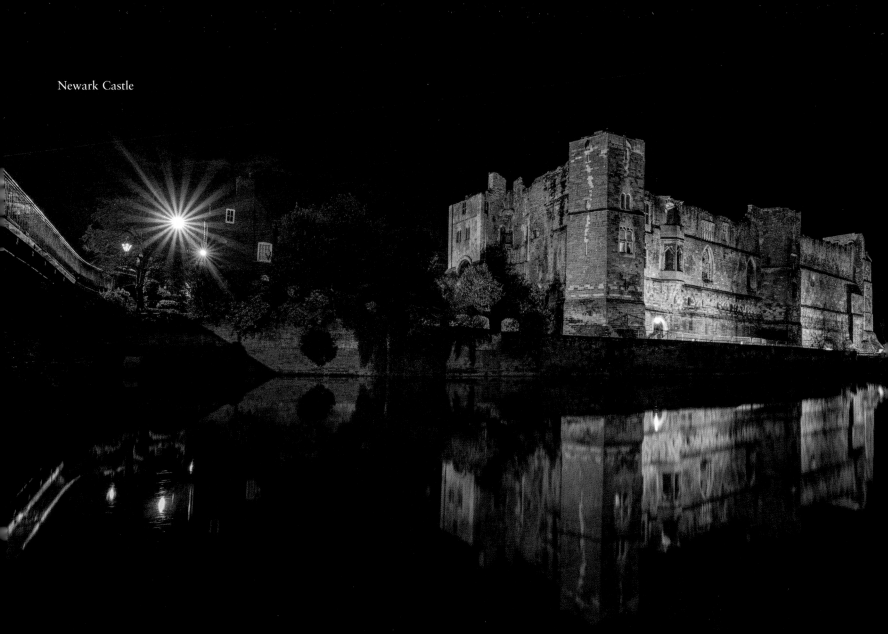

Newark Castle

Lincoln

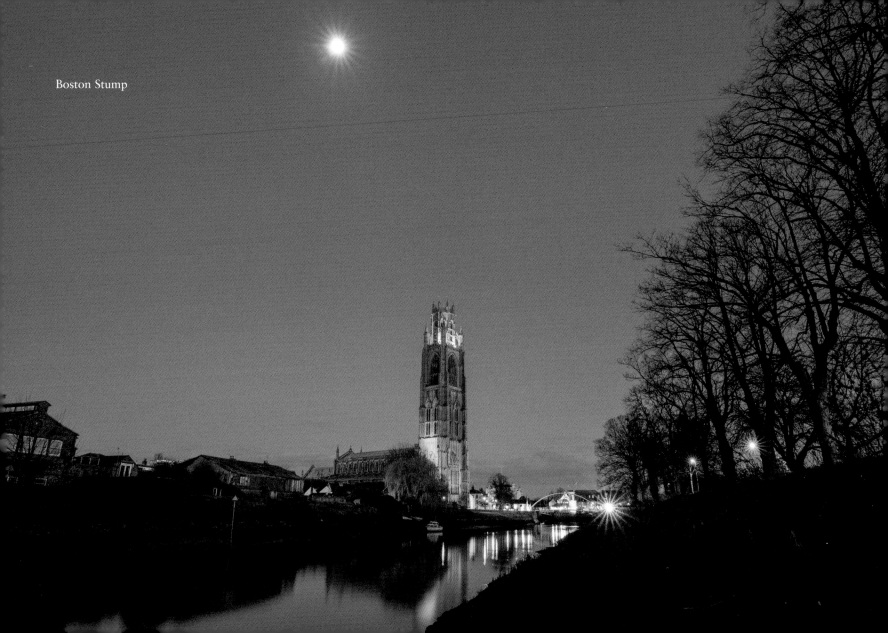

Boston Stump

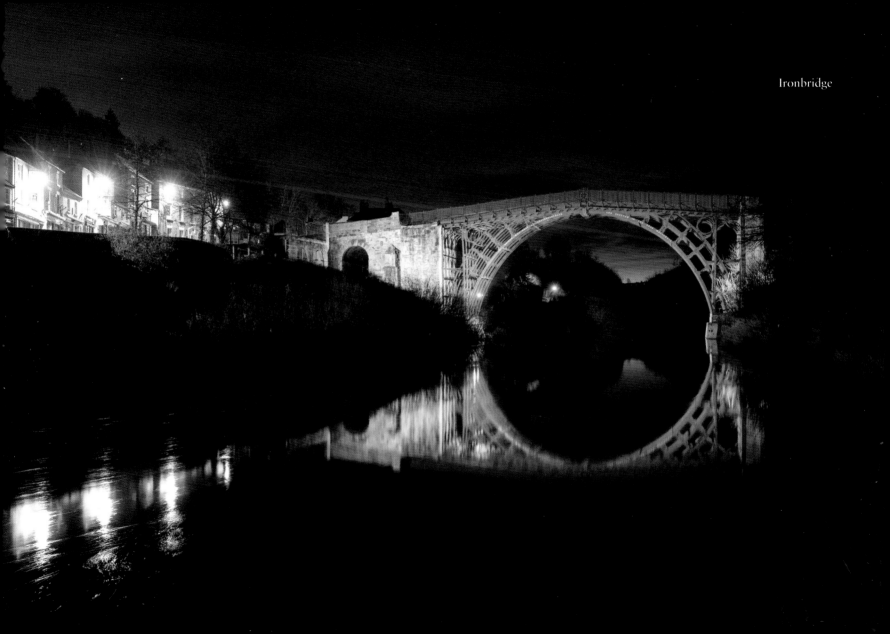

Ironbridge

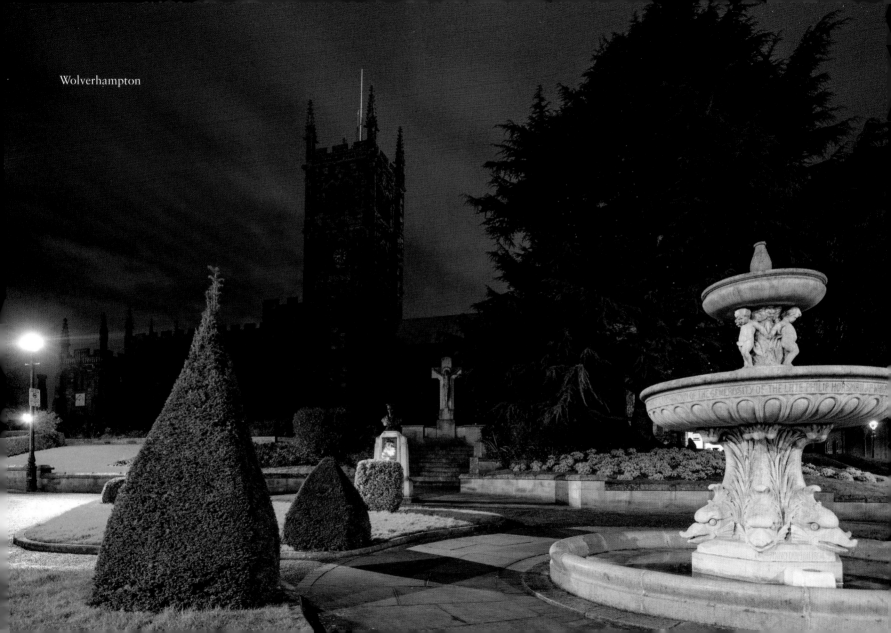

Wolverhampton

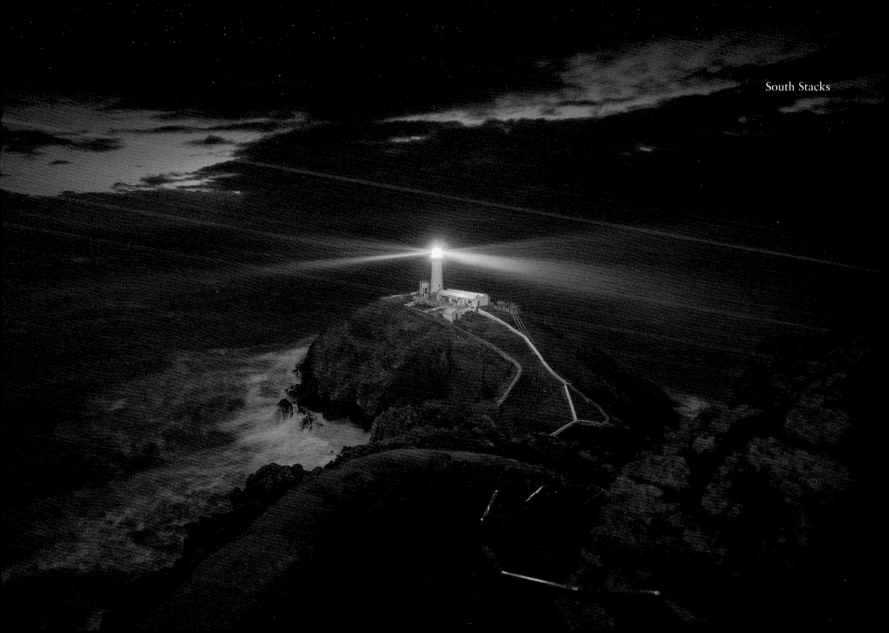

South Stacks

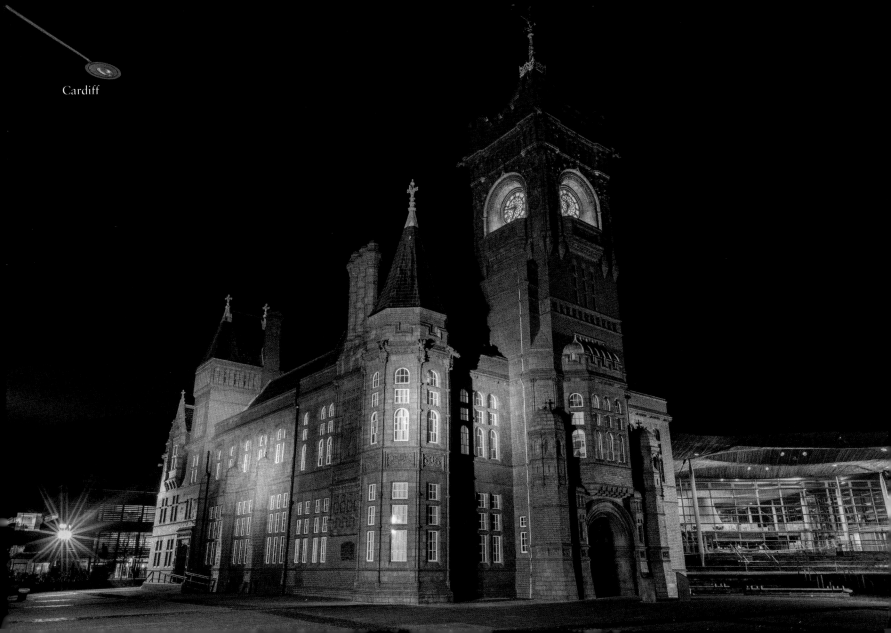
Cardiff

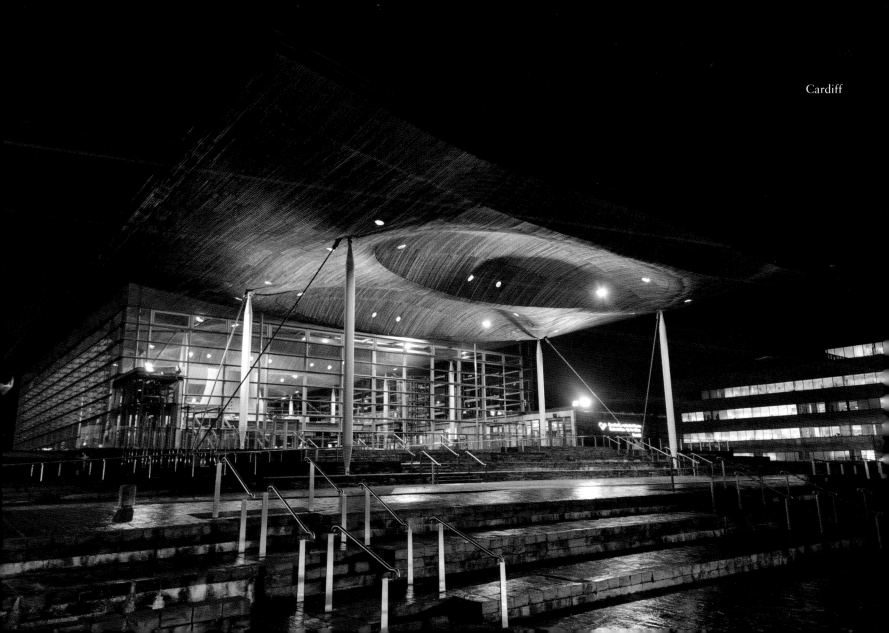

Cardiff

Wales Millennium Centre, Cardiff

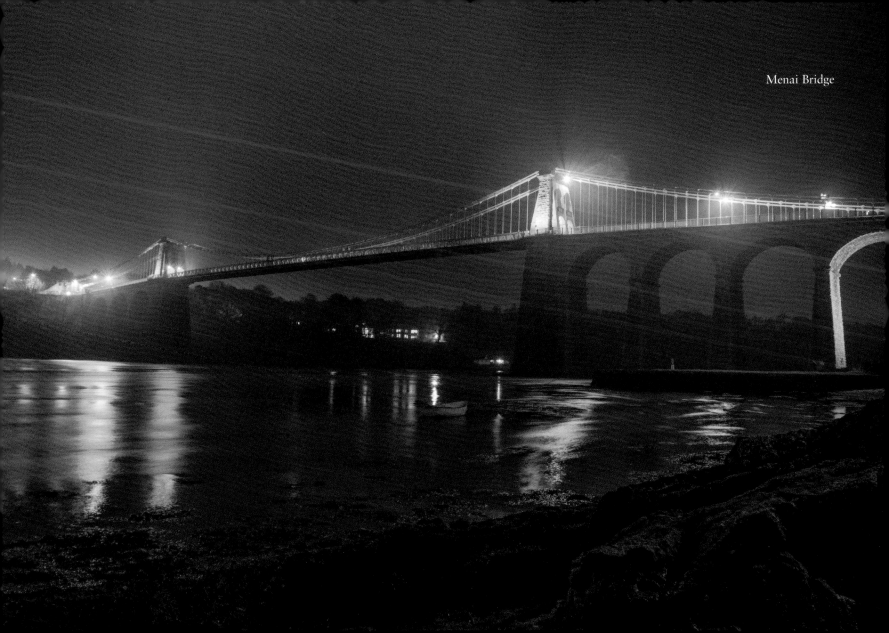
Menai Bridge

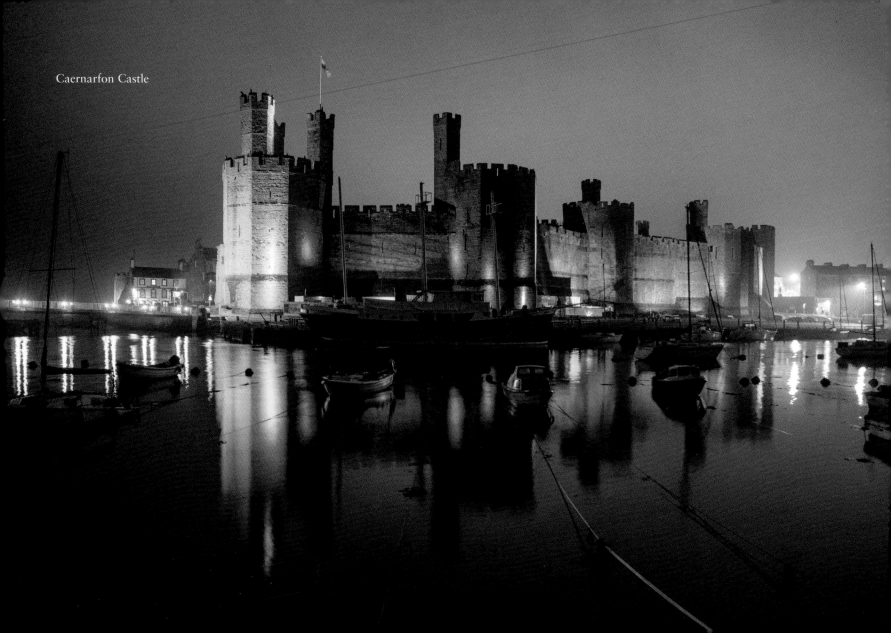

Caernarfon Castle

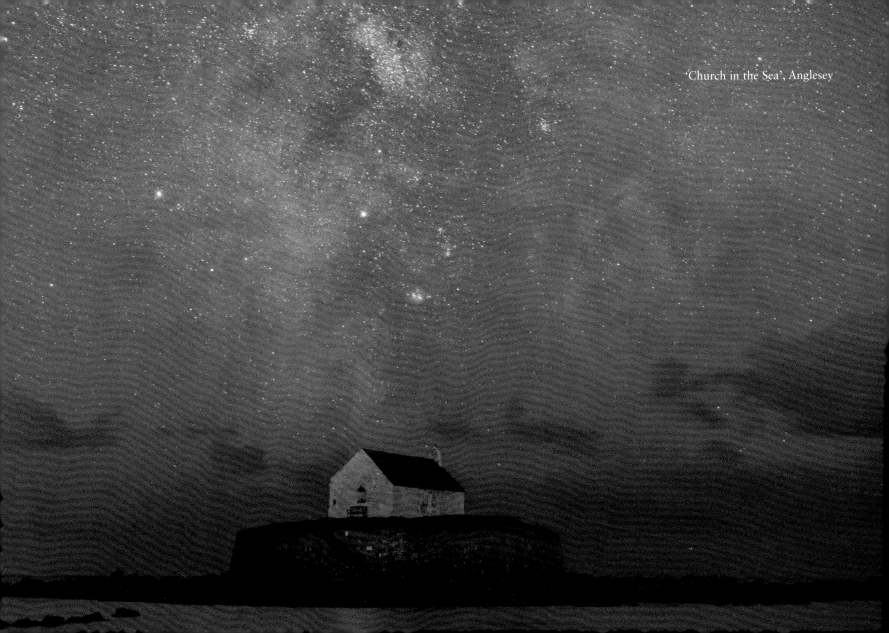
'Church in the Sea', Anglesey

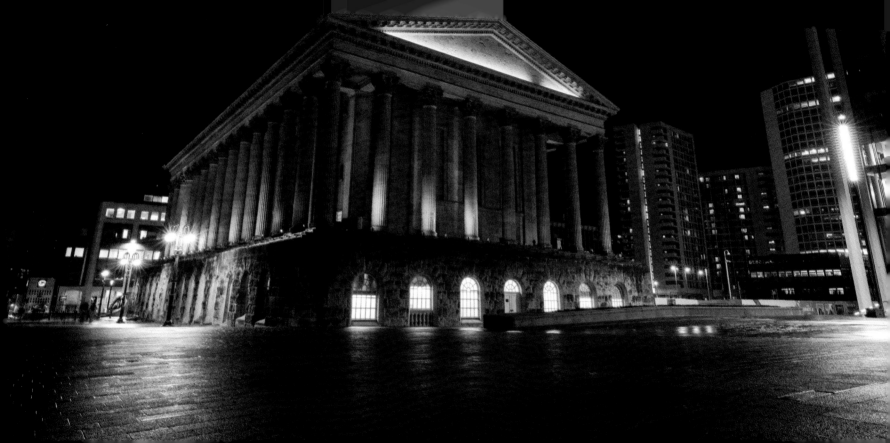

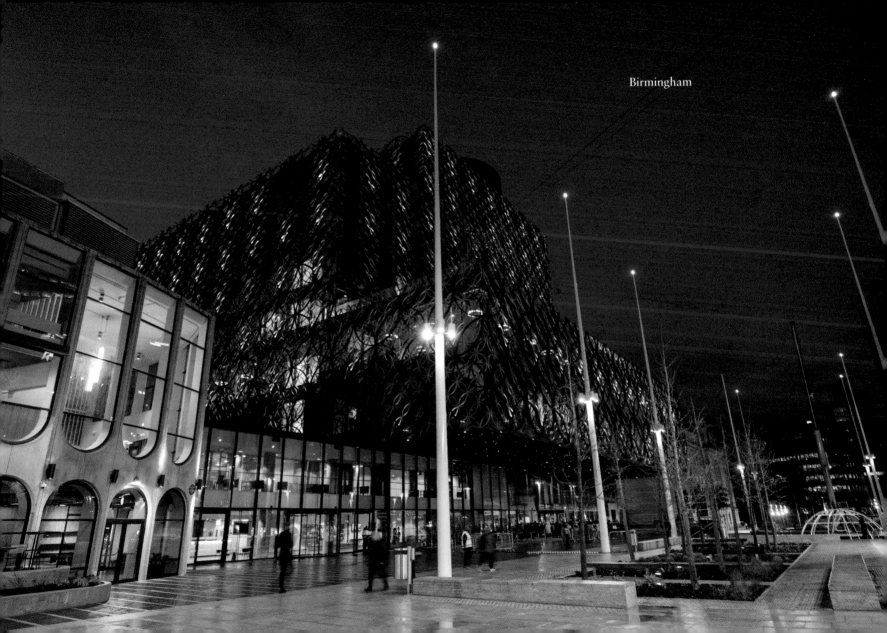

Birmingham

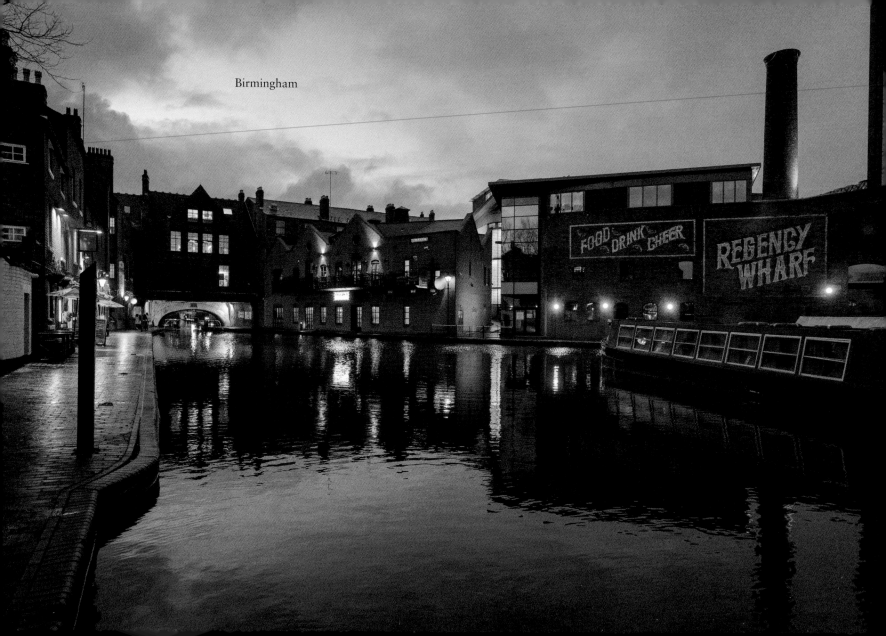

Birmingham

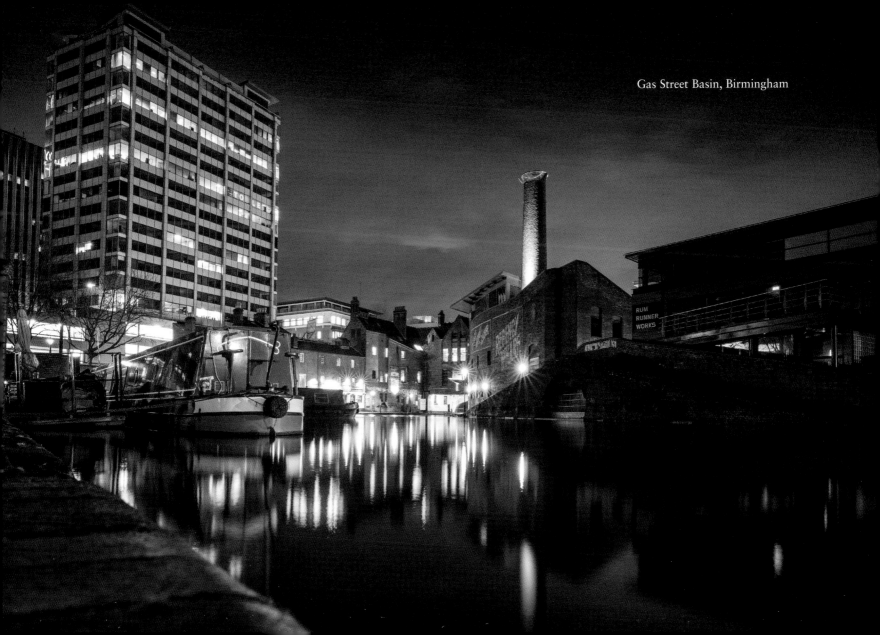
Gas Street Basin, Birmingham

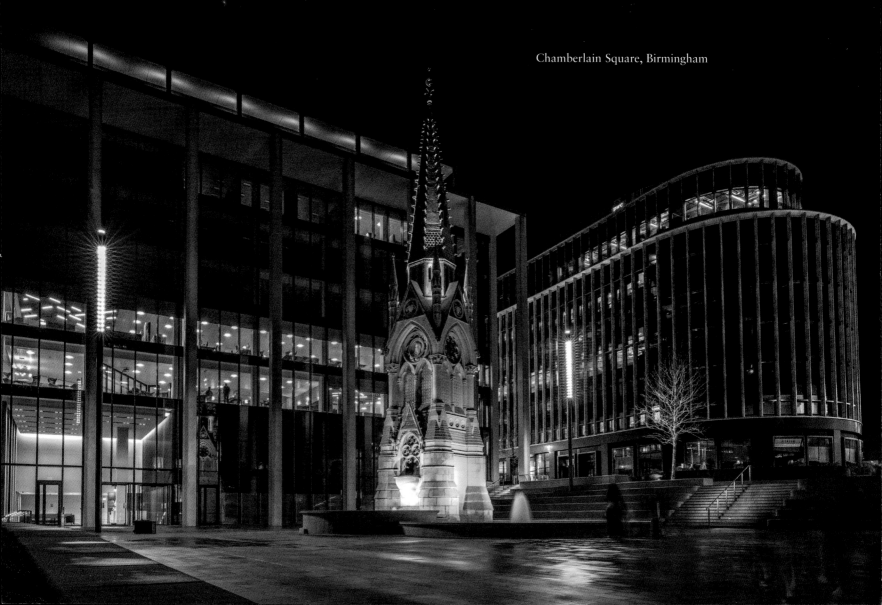

Chamberlain Square, Birmingham

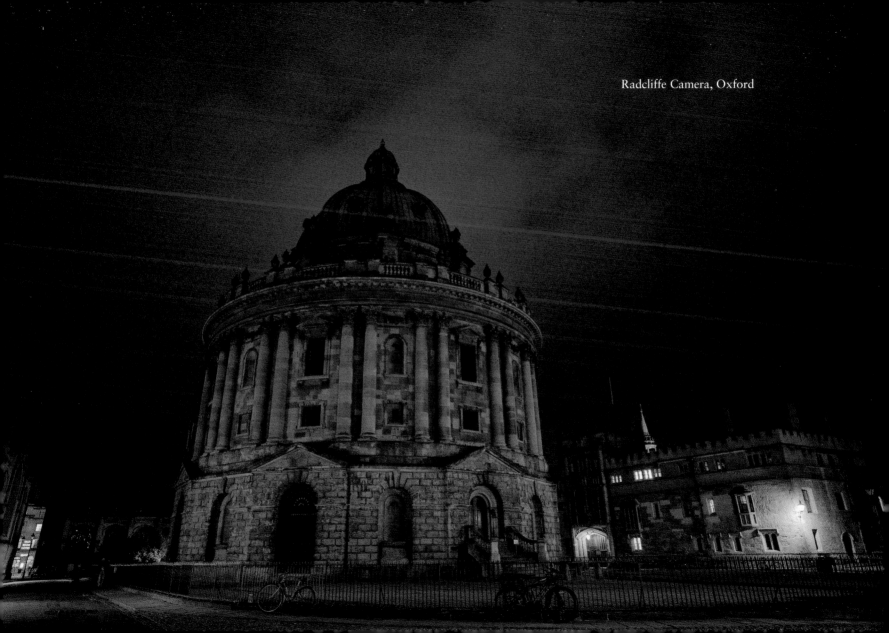
Radcliffe Camera, Oxford

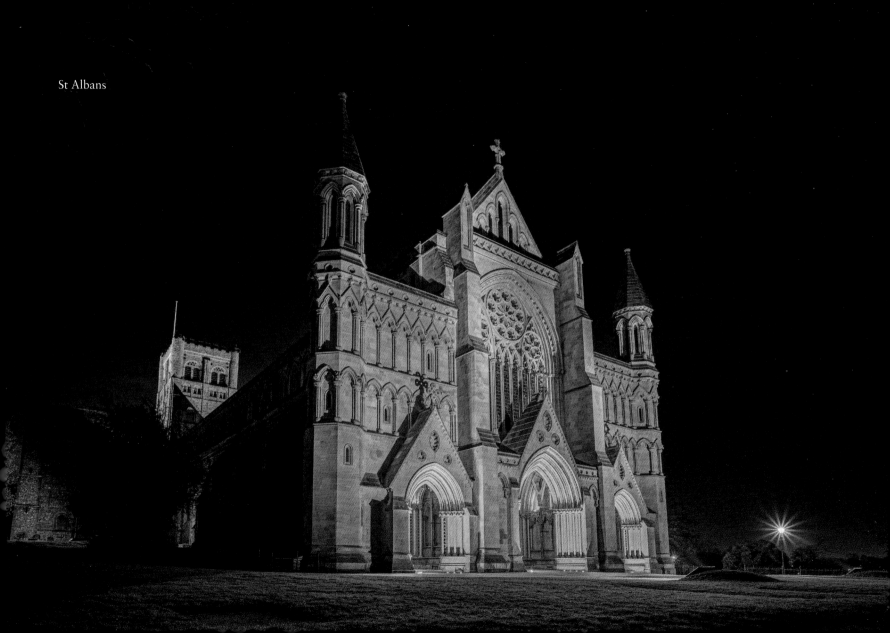

St Albans

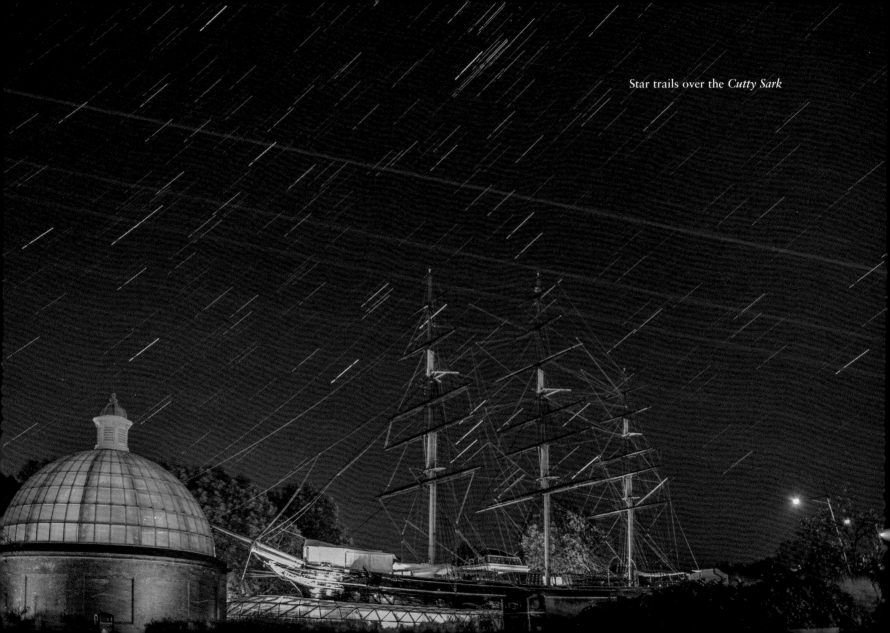

Star trails over the *Cutty Sark*

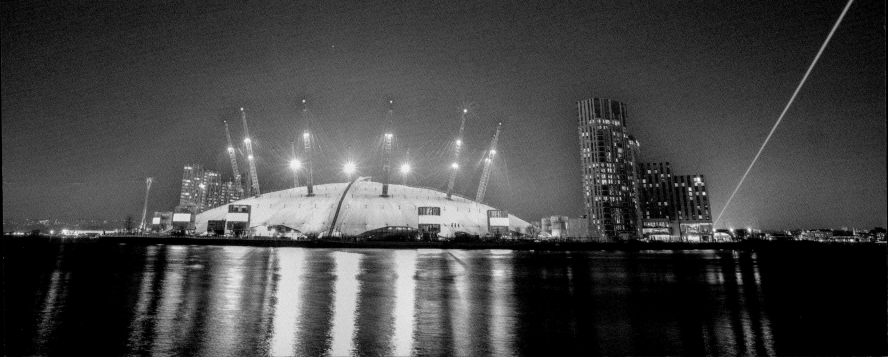

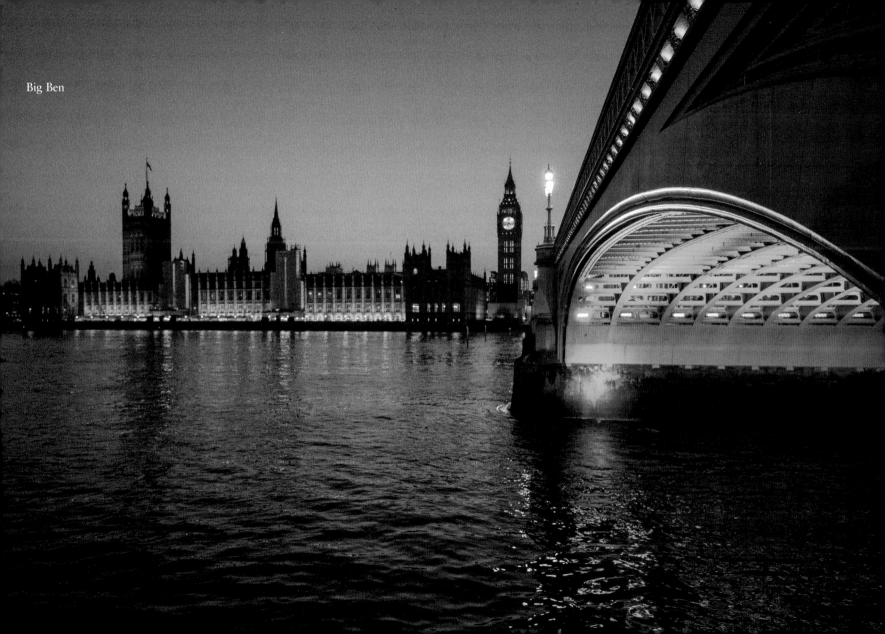
Big Ben

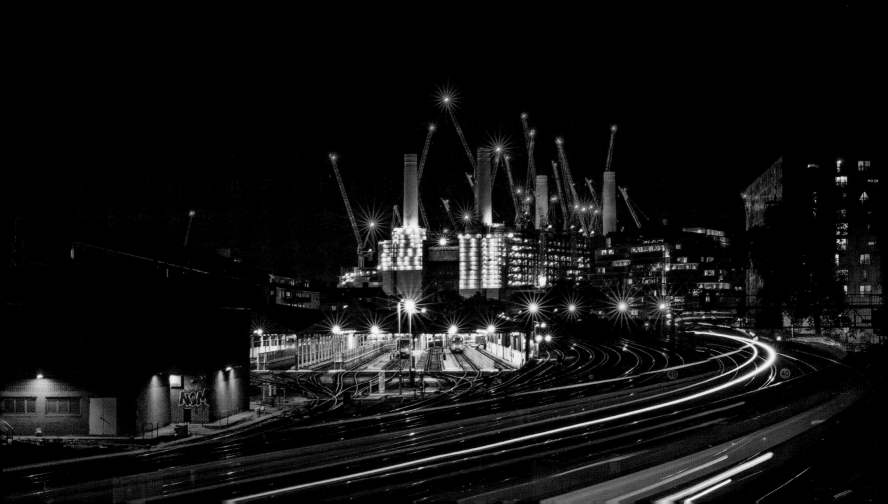

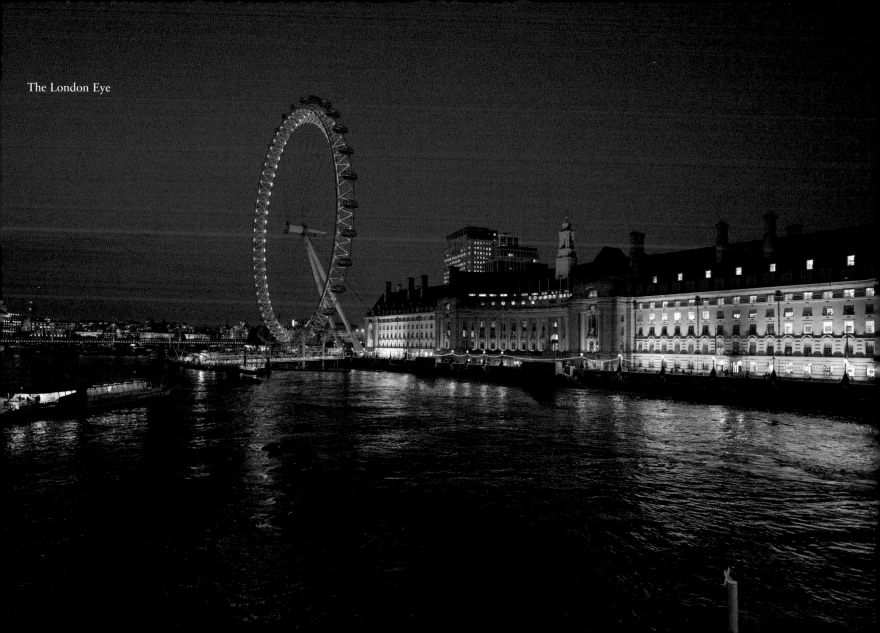
The London Eye

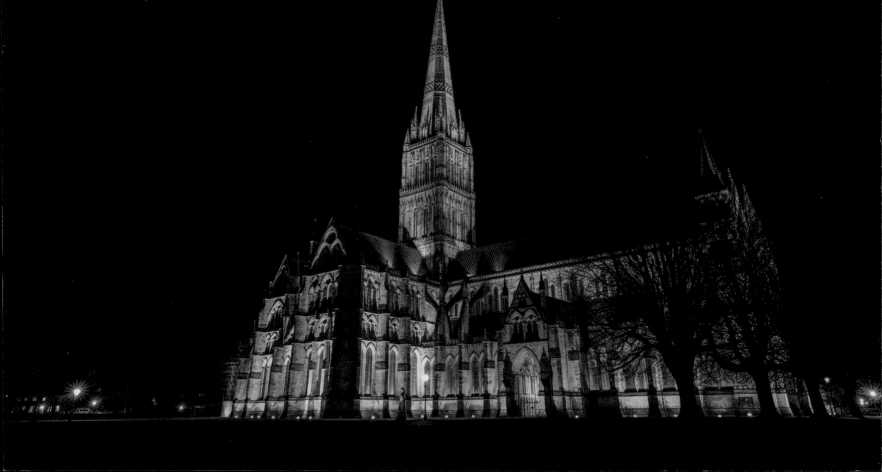

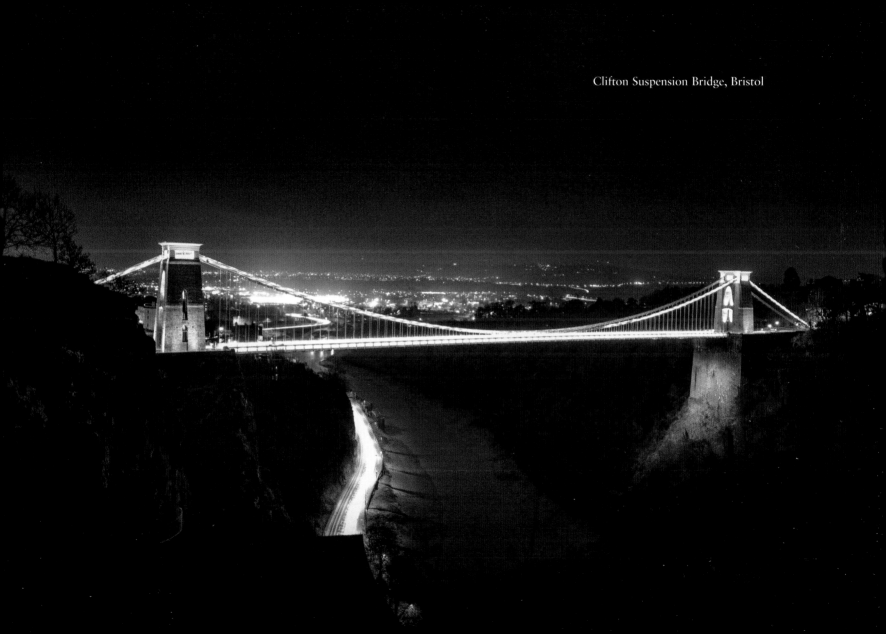
Clifton Suspension Bridge, Bristol

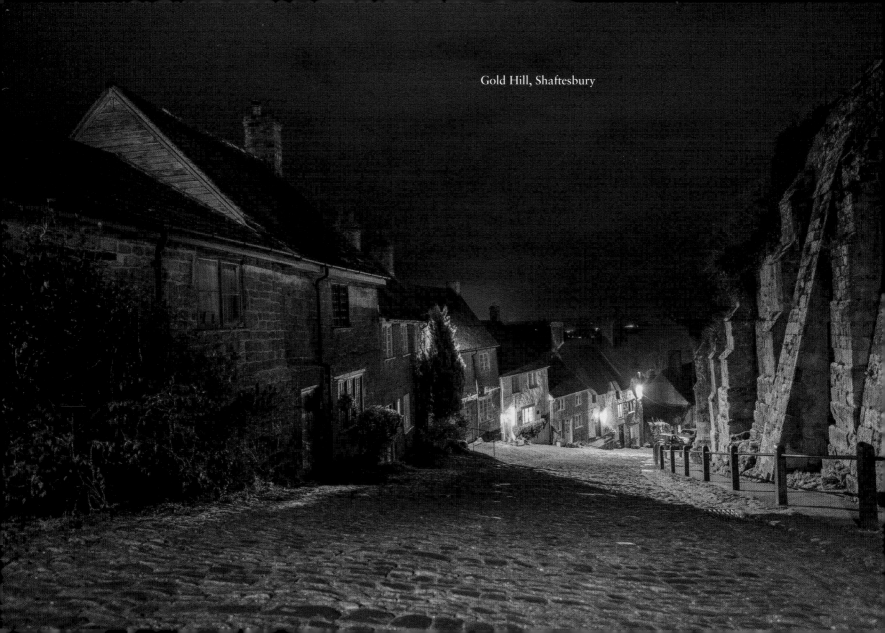

Gold Hill, Shaftesbury